LIVERPOOL
CITY CENTRE
THROUGH TIME
Ian Collard

AMBERLEY

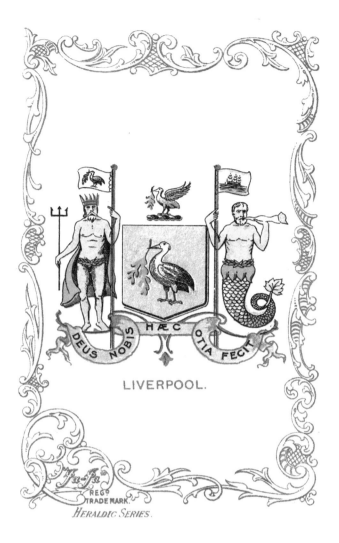

LIVERPOOL.

HERALDIC SERIES.

First published 2011

Amberley Publishing Plc
Cirencester Road, Chalford,
Stroud, Gloucestershire, GL6 8PE

www.amberley-books.com

Copyright © Ian Collard, 2011

The right of Ian Collard to be identified as the
Author of this work has been asserted in accordance
with the Copyrights, Designs and Patents Act 1988.

ISBN 978 1 4456 0412 1

British Library Cataloguing in Publication Data.
A catalogue record for this book is available from
the British Library.

Typeset in 9.5pt on 12pt Celeste.
Typesetting by Amberley Publishing.
Printed in the UK.

Introduction

There is much speculation regarding the origin of the name 'Liverpool'. 'Pool' appears to refer to the ancient tidal creek which was on the site of Canning Place, Paradise Street and Whitechapel. Dr Eilert Ekwall (1877-1964) thought that the name was derived from 'lifrig', later 'livered', as in the phrase 'the livered sea'. Therefore, Liverpool was the livered pool or pool with thick water. In the tenth century, Vikings reached the Wirral and landed at places along the Lancashire coast. Settlements in the area were given Scandinavian names such as Thingwall, Derby, Toxteth and Kirkby.

At the time of the Domesday Survey in 1087, it is claimed that Liverpool was one of the six unnamed 'berewicks' or sub-manors of the manor of West Derby, which was the capital of the administrative district named 'wapentake' or 'hundred'. It is claimed that the Anglo-Norman aristocrat Roger the Poitevin built the castle at West Derby. He acquired a great lordship in England, including land which was later known as Lancashire.

Following his visit to Lancashire in 1178, King Henry II gave the area between Islington and Great Nelson Street to his falconer, Warine de Lancaster. His son Henry was granted the land in 1192 by Prince John, who was the lord of the Honour of Lancaster. This was the first time that the name Liverpool was mentioned by name in a royal charter. Prince John also possessed the Lordship of Ireland, and was looking for a port to ship troops and cargo across the Irish Sea. Consequently, Liverpool was not included in the charter to Henry de Lancaster in 1199. John became King of England on 6 April 1199, and Liverpool was transferred to him on 23 August 1207. Letters Patent were issued soon after, creating Liverpool as a Borough and port.

One of the main consequences of this was a transfer of population from West Derby to Liverpool, and a castle was erected at Liverpool. King John was responsible for much of Lancaster to be disafforested, keeping some areas for hunting, such as Toxteth, Croxteth and Simonswood. Toxteth was extended by combining it with Smeedon or Smithdown, and the owner was given Thingwall in exchange.

The original streets of the Borough of Liverpool were laid out between the Pool and the river, with streets leading westwards to the riverside and eastwards inland. These were in the shape of a double-armed cross, and included Castle Street, Juggler Street and Mill Street, Bank Street and Chapel Street and Dale Street and Moor Street. Juggler Street became High Street, and is now incorporated into Exchange Flags. Mill Street, Bank Street and Moor Street became Oldhall Street, Water Street and Tithebarn Street in the sixteenth century.

The original corporate seal was lost, later recovered and destroyed in 1743. It bore the words: *Sigillum Conmune Borgensium De Leverpol* ('Common Seal of the Burgesses of Liverpool') with an eagle, inscribed *Johannis*, with the Plantagenet emblems of the broom sprig interpreted as a bunch of seaweed hanging from its beak. This became a cormorant by 1797, which has since been superseded by the Liver bird.

Around 1229, Henry III gave the land between the Ribble and the Mersey, including 'the borough of Leuerepul with all its liberties', to Ranulf de Blundeville, Earl of Chester. Ranulf died in 1232, and the South Lancashire fief was passed to his brother in law, William de

Ferrers, Earl of Derby. In 1235, the Earl received permission to construct his castle of Liverpool. Parts of the moat still exist below Derby Square, with a deep passage running down to Castle Street and the great tower built on the land where the Victoria Monument now stands. In 1266, Robert de Ferrers forfeited his lands for treason, and the king brought together the area between the Ribble and Mersey with the Honour of Lancaster, which he gave to his youngest son Edmund Crouchback, making him the Earl of Lancaster.

The town returned members of Parliament as a borough in 1295 and 1307, and was visited by King Edward II in 1323. Royal charters of confirmation were granted in 1333 by Edward III and Richard II in 1382. The first evidence of the appointment of a mayor was in 1352. The Bodleian map of Britain, dating from 1340, shows that Liverpool was a very small town in comparison with Chester. There were eighty-six households contributing to the poll-tax in 1379, and of these twenty-six were in agriculture, eighteen were brewers, nine servants, nine cobblers and shoemakers, five fishmongers, four drapers, three tailors, two smiths, the mayor, a franklin, a tanner, a dyer, a butcher, a carpenter, a chaloner, a weaver and a baker. There were few merchants in the town at this time, and shipping and maritime-related industries were few.

Liverpool at this time formed part of the ancient parish of Walton, forming one of the 'quarters' into which the parish was divided. However, in the fifteenth century, there were two chapels at the river end of Chapel Street. The largest was dedicated to Our Lady and St Nicholas, and the smaller was St Mary del Quay, at the water's edge, but this was demolished in 1814. A Benedictine priory existed on the opposite shore of the River Mersey, at Birkenhead, and the monks obtained a royal grant to operate a ferry from there to Liverpool.

Open fields and commons surrounded the small township on the banks of the Mersey, with arable land covering the area now known as Scotland Road, Vauxhall Road and Great Howard Street. In the south, up to Toxteth Park, were commons, heath and moss where peat was obtained. The Moore family purchased the manor of Kirkdale around 1400, and lived in Bank Hall and Oldhall Street. The Crosse family were from Wigan and lived at Crosse Hall, which is now Crosshall Street in the city centre.

In 1406, Sir John Stanley was given permission to fortify his house at the bottom of Water Street, and Tower Buildings is now on that site. Sir John Stanley was granted the lordship of the Isle of Man by King Henry IV in 1405, and the house was convenient for the family to sail to the Island. King Henry VI granted the hereditary offices of Steward of the Wapentake of West Derby, Master Forester of West Derby and Constable of Liverpool Castle to Sir Richard Molyneux. In 1425, a battle between the Stanleys and the Molyneux supporters nearly took place in the town but the dispute was resolved by the Sheriff of Lancaster.

In the fifteenth century, the burgesses gained control of the 'common, which was later used as building land to extend the size of the town, and Leland wrote in 1540 that 'Irish Merchants come much thither, as to a good haven', and that there was 'good merchandise' and 'much Irish yarn that Manchester men do buy there'. These were the early days of the Industrial Revolution, when goods such as Irish flax were imported through Liverpool for manufacture in the Lancashire mills.

The Borough was again represented in Parliament in 1545, and the two members were chosen by the Chancellor of the Duchy and the Earl of Derby. However, in 1563 the burgesses elected their own representative who took his seat in Parliament. By the middle of the sixteenth century, the town was led by the mayor and two bailiffs and a number of Mayor's Brethren, who were later called aldermen. Merchant Praisers were appointed to assess the rate to be levied. There were the Keepers of the Keys of the Common Coffer, a Sargeant at Mace, Water Bailiff, Town Customer, Keeper of the Common Warehouse, two Stewards of the Common Hall, two Levelookers, two Setters of Fleshboards, two Sealers of Leather, two Booth Setters, two Collectors of Cart Money, two Alefounders, four Scavengers or Overseers for Cleansing Streets, two Moss Reeves, a Hayward and a Wait or Town's Musicioner. The town clerk and recorder were permanent offices.

At the beginning of the seventeenth century Liverpool had a population of around 2,000 people. In the Civil War (1642-1646), the majority of the townsmen supported the Roundhead cause, but many of the nobles and gentry were Royalist and they controlled the Castle and the Tower. Liverpool was initially in Royalist hands, but they were defeated in 1643 and John Moore became Governor.

It was at the end of the seventeenth century that the trade to America began to expand, with the importation of West Indian sugar and Virginia tobacco and the increase in exports of Lancashire textiles. The coalfields were developed across Lancashire, and this was exported through Liverpool. Sugar refineries, salt and glass works, metal crafts and potteries were established in the town, and Cheshire rock salt was exported through the port.

By 1698, the town had twenty-four streets, and the population had increased to over 6,000 people. Liverpool became a separate parish the following year, and a second parish church was built and dedicated to St Peter. It was built in 1704 and survived until 1922, when it was demolished. Sir Thomas Johnson was a major businessman in the town, being involved in the tobacco trade. He was also elected as Member of Parliament until he had to give up his seat in 1722 following customs irregularities, after representing the borough for twenty-one years.

Thomas Steers began the construction of the first wet dock to be constructed in the town in 1710, and it was opened in 1715. Paradise Street and Whitechapel were built on the sections of the Pool that were drained following the construction of the new dock. Improvements were made to the road that ran from Liverpool to Prescot in 1726 by a Turnpike Trust, and this was further extended to Ashton-in-Makerfield several years later. The roads from Liverpool to Preston and Birkenhead to Chester were made also made turnpike roads at the end of the century, and a stagecoach service between Liverpool and London began 1761.

An Act of Parliament was passed in 1720 for making the rivers Mersey and Irwell navigable from Liverpool to Manchester. Further Acts were passed to make the River Douglas navigable between the Ribble and Wigan in 1719, and the River Weaver between the Mersey and Northwich the following year. The Sankey Canal was used to bring coal to Liverpool from St Helens, and the Bridgewater Canal, Grand Trunk Canal and the Leeds and Liverpool Canal were all completed.

The population of the town increased from 6,000 in 1700 to 20,000 in 1750, and 80,000 in 1800. The number of ships using the port increased from 102 in 1700 to 4,746 in 1800, and land was developed creating Hanover Street, Park Lane and Duke Street. Williamson Square, Clayton Square, Cleveland Square, Wolstenholme Square and St Pauls Square were all completed. The Bluecoat School for orphan boys was opened in 1708, the Royal Infirmary between 1745 and 1749, and the Seamen's Hospital in 1752. The Town Hall was constructed between 1749 and 1754, and was reconstructed in 1795 following a serious fire which damaged the building.

The slave trade contributed to the prosperity of the town. Goods were shipped to Guinea, where slaves were bought and then taken to the West Indies where they were sold and the vessel returned to Liverpool with a cargo of sugar, molasses, rum or cotton. Fifteen ships a year were involved in this trade in 1750 and 100 a year by 1770. The last British ship involved in the trade left Liverpool in 1807 shortly before the trade was abolished.

Shipbuilding was established in the town, and by 1790 about one ship in every twenty in the country was built in Liverpool. Pottery was manufactured in the area around William Brown Street, and good-quality watches were assembled from parts manufactured around Prescot. Rodney Street was built between 1783 and 1825, and Abercromby and Falkner Square were completed at the same time. William Roscoe encouraged the establishment of the Athenaeum in 1799, the Botanic Gardens in 1802, the Lyceum in 1803, the Academy of Art in 1810, the Literary and Philosophical Society in 1812 and the Royal Institute in 1817.

The Liverpool & Manchester Railway was founded on 24 May 1823 to transport goods between the Port of Liverpool and Manchester. The thirty-five miles of track was opened in 1830, and soon became popular with passengers as it was cheaper and more comfortable than travelling by road. Imported raw materials were shipped from Liverpool and manufactured goods sent by rail to the port to be exported by ship.

At the beginning of the nineteenth century, the main trade through the port was to and from the West Indies. The trade with the United States increased gradually, and the American Chamber of Commerce was founded in Liverpool in 1805, with the Canadian and Newfoundland trade increasing at the same time. The port had increased its trade with the British colonies throughout the seventeenth and eighteenth centuries, and the London merchants preferred to ship goods from America to Liverpool and transport them by land to the south of England.

Commercial traffic had increased dramatically during the American War of Independence, and King's, Queen's, Princes and Coburg Docks were built. The new Custom House was completed in 1839, and Brunswick Dock was opened in 1832 for the timber trade. Waterloo, Clarence and Victoria Docks were built for the coastal trade. The famous Albert Dock and warehouses were completed in 1846 and officially opened by Prince Albert.

It was in this period that the Corporation faced the threat of competition from the Harrington Dock Company and a group led by Sir John Tobin and William Laird in Birkenhead. The Dock Board took over the Harrington Dock Company in 1843 at a cost of £253,000, and in 1855 Liverpool Corporation purchased the Birkenhead Dock Company. However, over the following years, merchants became dissatisfied as they felt that the dues

paid to the Corporation were being spent on the town of Liverpool, and not the harbour or the facilities at the docks.

A Royal Commission was appointed in 1853 to investigate the complaints, and it recommended that a new body be formed to take over the running of the docks. A bill was introduced in 1857, and after a long and expensive struggle it was passed by both Houses of Parliament. The Mersey Docks and Harbour Board was created, which was responsible for all the port accommodation and controlled by twenty-eight Dock Trustees.

The first work it undertook was to build Canning Dock for the timber trade, and construct Herculaneum Graving Docks. In 1873, an Act of Parliament was passed to enable the Board to spend £4 million to construct Langton, Alexandra and Hornby Docks. A further £3 million was spent on deep-water berths at Langton and Canada docks, and a new graving dock was built at Canada Dock. The water was run out of George's Dock in 1900 for the Mersey Docks and Harbour Board to build their new headquarters accommodation. The Liver Building and Cunard Building were later built to the north of this site. The 1906 Act of Parliament allowed the Board to construct Gladstone Dock and Gladstone Graving Dock, which were opened by King George V on 11 July 1913.

The Cotton Exchange had been erected in Exchange Buildings behind the Town Hall in 1803-8, and the corn merchants had built their own exchange in Brunswick Street; a new Cotton Exchange was erected in Oldhall Street in 1906. Geographically, the port was able to take advantage of providing the Lancashire cotton industry with a convenient way of importing their raw materials and shipping the finished products around the world.

The Municipal Reform Act of 1835 ended the Common Council which, from 1750, had discouraged the admission of new freemen by purchase. Consequently, people like William Roscoe were debarred from the Council, and from voting at mayoral and parliamentary elections. Bribery and corruption was rife, and Liverpool was described as being 'the biggest rotten borough in England' by Brougham.

However, Liverpool had pioneered many of the advances in public health in this period. William Henry Duncan was appointed as the Britain's first Medical Officer of Health in 1846 and set up public washhouses and baths. The water supply was improved by bringing water from Rivington and North Wales. Public libraries were opened following the initiative of J. A. Picton, and in 1860 a new library and museum was opened following a gift from Sir William Brown. The Art Gallery was built, and the Picton Reading Room was added to the library in 1879. St George's Hall had been designed as a concert hall, and assize courts were built in 1838-54, designed by Harvey Lonsdale Elmes.

Primary education was provided by various charity schools, such as the Bluecoat School, which was established in 1708, and Moorfields Charity School of 1789. However, in 1835 it was found that only half the children in Liverpool were receiving formal education, and this was improved dramatically by the creation of School Boards under the Education Act of 1870. The Mechanics Institution enabled students to be prepared for degrees of the University of London, but this arrangement ended in 1881. A new college was established; the site was provided by the Corporation, and the Victoria Building and Clock Tower were constructed in 1887-92. By 1903, the college merited the conferment of the status of an independent University of Liverpool.

Bootle was granted a charter as an independent Borough in 1868, and in 1895 Walton, Wavertree, West Derby and Toxteth became part of Liverpool. Garston was added in 1902, Fazakerley in 1905, Allerton, Childwall, Little Woolton and Much Woolton in 1913, the remainder of West Derby and Croxteth in 1928 and Speke in 1932. Liverpool was granted City status by royal charter in 1880, when it also became the seat of a new diocese which included part of Chester and south-west Lancashire. The Roman Catholic Church had made Liverpool the seat of a diocese in 1850, and two great cathedrals were built in the city in the twentieth century.

The people of Liverpool suffered tremendously in the bombing of the Second World War, especially in the May blitz between 1 May and 8 May 1941. The city and docks were bombed continuously over this period, and sustained damage and loss of life to residents and workers. When Huskisson No 2 Dock received a direct hit, the Brocklebank vessel *Malakand*, which was loaded with ammunition, exploded and devastated the whole area. However, the City Council had prepared plans for the future, and when the war ended many of these were implemented. These included building new housing estates, and demolishing old insanitary houses and creating new communities in Speke, Fazakerley and Kirkby.

The City of Liverpool has changed dramatically in the last 100 years, but the majority of the buildings in the city centre were constructed in Victorian times and still retain their charm and distinctive character. It is a city steeped in history, but one which is also looking forward to its rightful place in modern Britain. It is the country's second largest port, and has been the major gateway for people arriving from Northern Ireland and the Irish Republic.

Over 8,000 people work in major firms in the commercial district of the city. The area around Old Hall Street was rebuilt in the 1970s. Many of the Victorian buildings have been converted to residential accommodation and also provide leisure, retail and recreational facilities. The former Littlewoods centre has been refurbished and high-quality office space provided in various new buildings such as the Beetham Tower, completed in 2004.

Liverpool celebrated its 800th anniversary in 2007, and became European Capital of Culture the following year. The City Centre has been transformed in the last few years by the opening of the new Liverpool One shopping development. Grosvenor's £1 billion project provides retail, leisure, residential facilities and office accommodation. It includes the provision of large department stores, hotels, cinema, cafes, restaurants, bars and a new bus station. There are further plans to regenerate the city centre to ensure that it remains as one of the major tourist, commercial and business centres of the north-west of England.

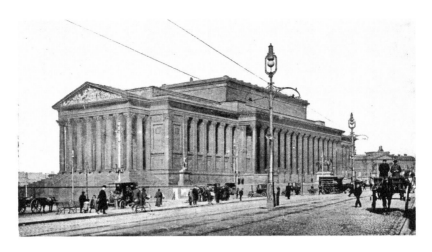

St George's Hall

St George's Hall was opened on 18 September 1854 at a cost of £380,000. It was designed by Harvey Lonsdale Elmes and built on the site of the Liverpool Infirmary. A company was formed in 1836 to raise subscriptions for a hall which would be used for festivals, concerts, dinners and meetings. Shares were offered at £25 each, and in 1838 the foundation stone was laid to commemorate the coronation of Queen Victoria. Elmes included provision for an assize court in the plans for the building, and work began in 1841. However, Elmes died in 1847 and the work was continued under John Weightman, with Robert Rawlinson as the structural engineer; Sir Charles Cockerell was appointed as architect in 1851. The main entrance is in the centre of the east facade, approached by a flight of steps where there is a statue of Benjamin Disraeli. The building is 490 feet long and incorporates two courtrooms, a central hall and a Concert Hall, together with ancillary rooms. At the time this photo was taken, most of the vehicles at this time were horse-drawn, but there are several private cars parked outside the Hall. A major restoration of the building took place costing £23 million, and it was reopened on 23 April 2007 by the Prince of Wales.

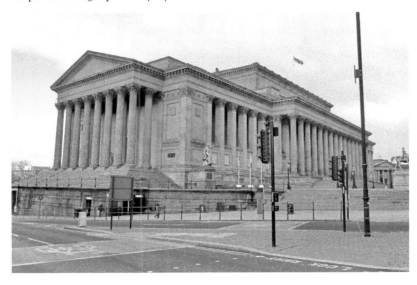

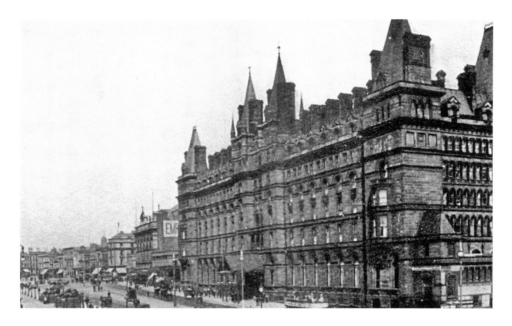

Great North Western Hotel

The former Great North Western Hotel in Lime Street was opened as a 330-room hotel in 1871. It was designed by Alfred Waterhouse, who was also responsible for the Natural History Museum in London and the Prudential Building in Dale Street, Liverpool. The building is built in the French Renaissance style and is faced with Caen and Storton stone. When the hotel was closed down the building was empty for a number of years, but now provides accommodation for students in 246 flats.

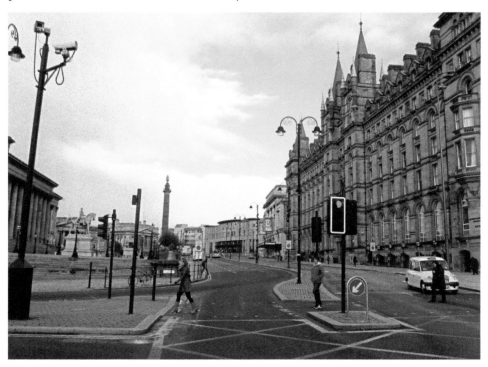

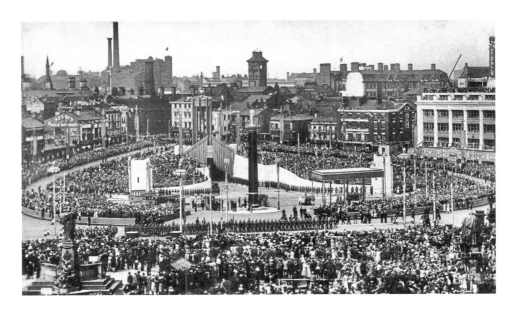

The Queensway Tunnel

The Queensway Tunnel entrance in Liverpool was opened by King George V and Queen Mary on 18 July 1934. Construction started in 1925, and the entrances, toll booths and ventilation buildings were designed by Herbert James Rowse. The tunnel is just over 2 miles long and has two dock branches leading to the Dock system on either side of the Mersey. However, the Birkenhead Dock branch was closed to traffic in 1965. The tunnel was provided with seven emergency refuges, costing £9 million, in 2004. Each has fire-resistant doors, access for wheelchairs, water supply, toilet and a link to the tunnel police control room and a walkway to the Birkenhead and Liverpool ends of the tunnel.

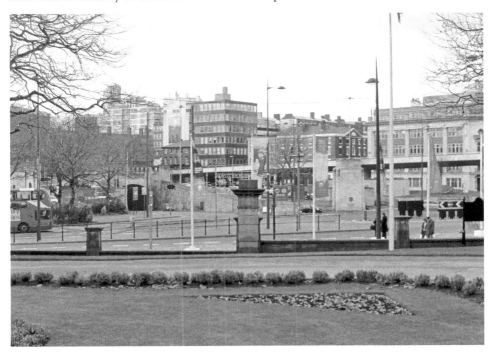

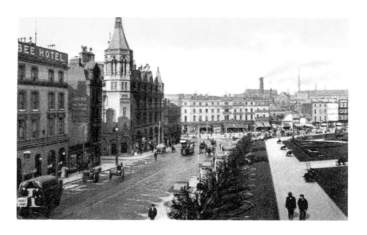

St John's Gardens

St John's Gardens was built on the site of St John's Church, which stood there from 1783 to 1887. The churchyard contained the graves of many French prisoners of the Napoleonic War who died in captivity in Liverpool. The gardens were laid out by Thomas Shelmerdine, who was the City Surveyor, and were opened in 1904. The garden contains several monuments, including the Gladstone Monument which was erected in 1904. The Liberal statesman and Prime Minister was born in Rodney Street in 1809, and died in 1898.The Rathbone Monument was designed by George Frampton, and was erected in 1889. William Rathbone was a merchant and philanthropist who was also a Member of Parliament for nearly thirty years. The Forwood Monument was also designed by George Frampton, and celebrates the life of the Tory Member of Parliament for Ormskirk, who died in 1898. The Balfour Monument, designed by A. Bruce Joy, was erected in 1898 and the Lester Monument, designed by George Frampton, commemorates Canon Major Lester, who worked with poor and neglected children of the city. The Nugent Monument was erected in 1906, and the Regimental Monument is of white stone and commemorates the war in South Africa. It was designed by Sir William Goscombe John.

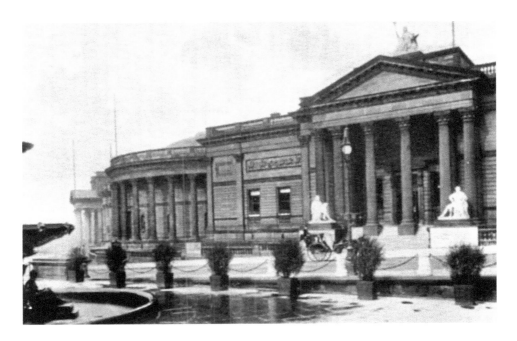

The Walker Art Gallery

The Walker Art Gallery was designed by H. H. Vale and opened in 1877. In 1819, the Liverpool Royal Institution was given a collection of William Roscoe's paintings, which were displayed in a gallery, and over the following years the collection increased as additional work was purchased. The William Brown Library and Museum opened in 1860 and exhibitions of the work were organised. Several attempts to organise public subscriptions to build an art gallery failed until Alderman Andrew Barclay Walker became mayor in 1873 and decided he would fund the building.

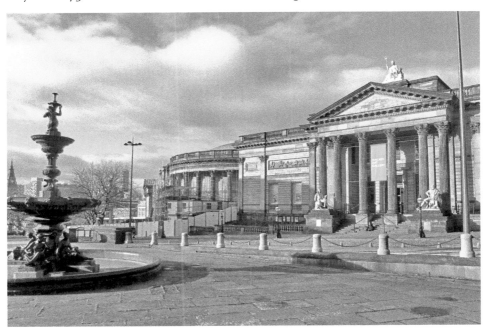

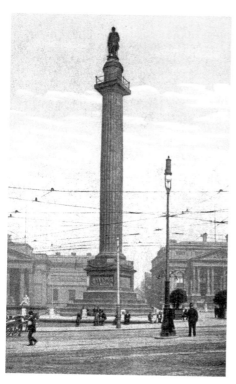

The Wellington Column

The Wellington Column was opened in 1863, and was designed by George Anderson Lawton. It is 132 feet high, built of Darleydale stone and commemorates the victories of the First Duke of Wellington in the Napoleonic Wars. The four sides of the plinth contain bronze reliefs, and the south panel depicts the charge at Waterloo.

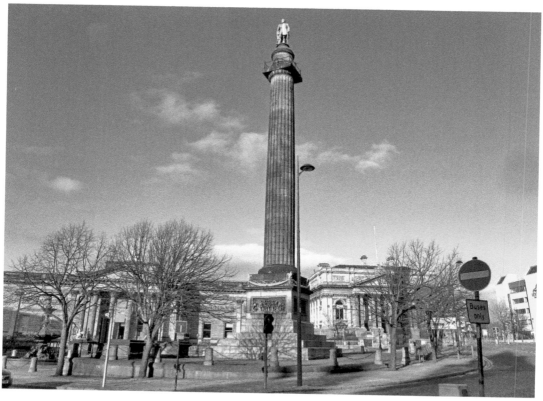

The Steble Fountain

The Steble Fountain is in William Brown Street and was designed by W. Cunliffe. It was erected in 1879 and comprises a circular stone basin with a bronze centrepiece of figures representing the four seasons. It was gifted to the city by Colonel R. F. Steble, the Mayor of Liverpool in 1874/75. It is situated near to the Wellington Column.

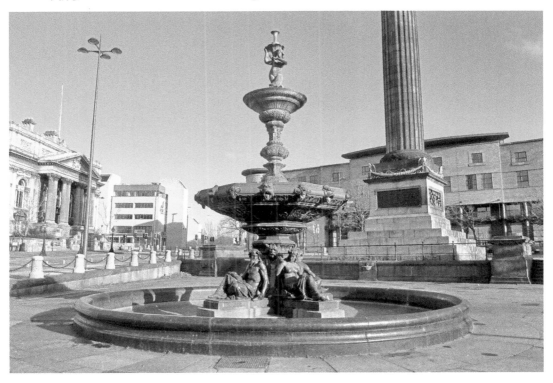

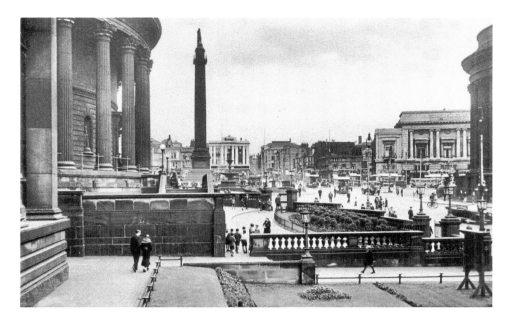

William Brown Street

A view of William Brown Street from the steps of the William Brown Library and Museum, which was designed by Thomas Allom and opened in 1860. It is a Grade II listed building and was designed as a replacement for the Derby Museum, which contained the Earl of Derby's natural history collection. It is built on Shaw's Brow and the funding was provided by Sir William Brown, First Baronet of Astrop. The original design was modified by John Weightman, who was the Liverpool Corporation architect. The building was bombed and severely damaged in the Second World War, especially during the air raids of 1941. However, much of the collection had been moved and was later placed on show when the museum re-opened.

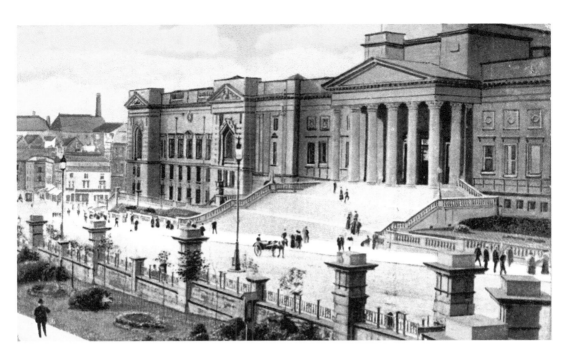

The William Brown Library

The William Brown Library and Museum from St George's Hall.

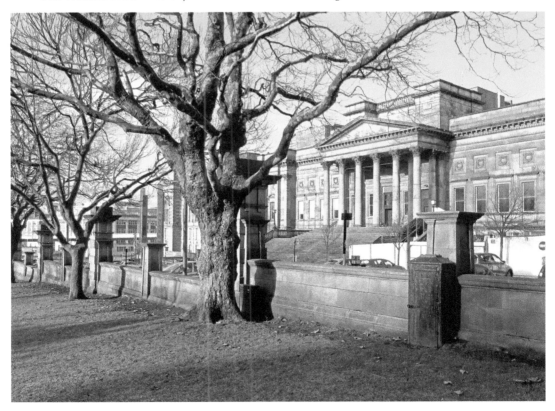

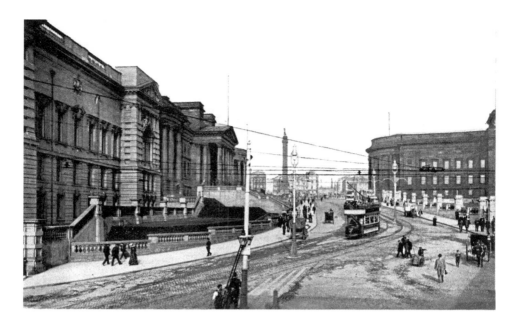

The Picton Reading Room

A tram passes up William Brown Street towards St George's Hall. The Picton Reading Room and Hornby Library can be seen on the right of the picture. These are Grade II listed buildings and now form part of the Liverpool Central Library. Sir James Picton, who was the Chair of the Libraries and Museums Committee, laid the foundation stone in 1875, and the building was completed in 1879. It was designed by Cornelius Sherlock and based on the British Museum Reading Room. Thomas Shelmerdine designed the Hornby Library, which was completed in 1906.

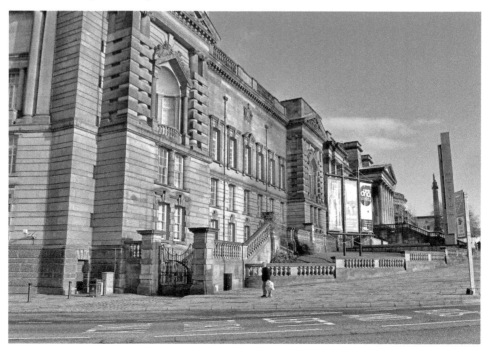

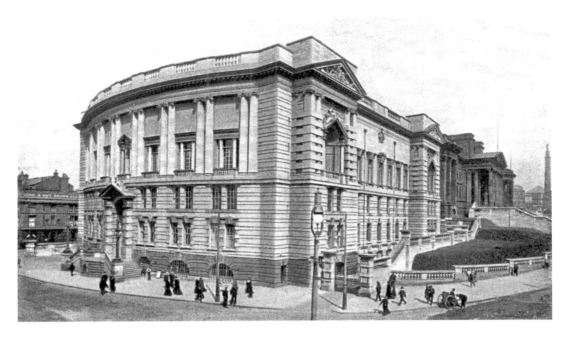

The Technical School

A view of the Technical School, College of Technology and Museum Extension, William Brown Library and Museum from the bottom of William Brown Street. The college was designed by E. W. Mountford, and was opened in 1902. This is the first view of Liverpool as visitors drive out of the Queensway Tunnel from Birkenhead.

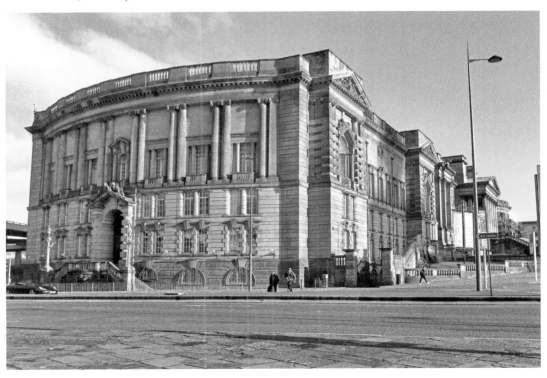

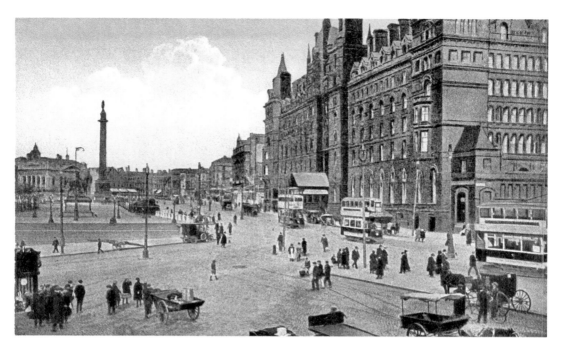

Lime Street

Lime Street, showing the former North Western Hotel, Empire Theatre and the Wellington Column. Lime Street was originally named Limekiln Lane. In the eighteenth century, limekilns stood on the site of the present-day main-line station. The kilns were demolished following complaints by the doctors of the Infirmary across the road regarding the effects of the fumes on their patients.

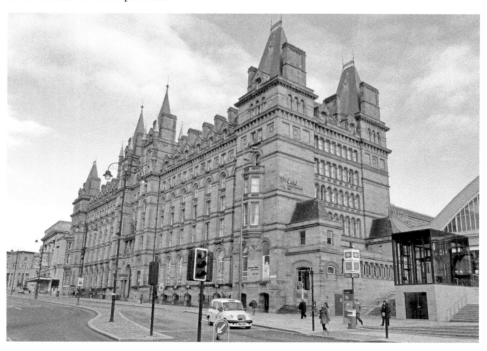

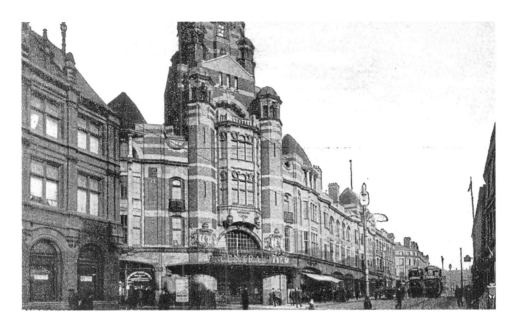

Central Hall

The Central Hall was a Wesleyan Methodist church which was opened on 5 December 1905, with a grand entrance tower and dome designed by Bradshaw & Glass of Bolton. It was built on the site of a Unitarian chapel, which dated from 1790, as a memorial to Charles Garrett, who died in 1900. It provided seats for 3,576 people, 1,788 in the large hall, 102 in the Orchestra, 858 in the stalls and 828 in the balcony. From 1933 to 1939 it housed the Liverpool Philharmonic Orchestra while the Philharmonic Hall was rebuilt. The building was sold in 1990, and was later opened as a nightclub and bar, and has also been used by traders from Quiggins.

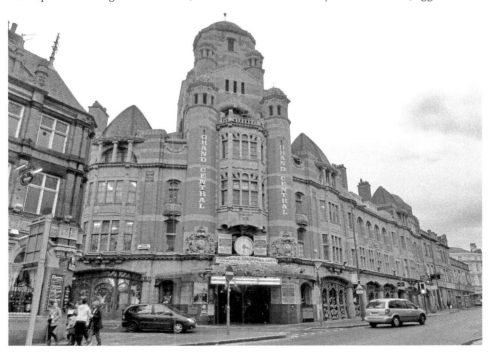

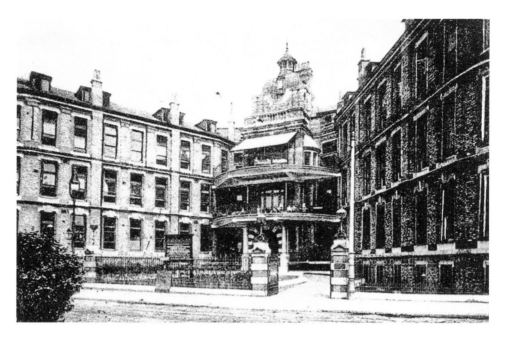

Liverpool's Children's Hospitals

The Liverpool Infirmary for Children was established in 1851, and the hospital in Myrtle Street was opened in 1866. However, this building was demolished, and the Children's Hospital was opened in 1907. The Liverpool Infirmary for Children and the Royal Liverpool Hospital for Children merged in 1920, becoming the Royal Liverpool Children's Hospital. The Myrtle Street Hospital ended in-patient services in 1989, and most of the other services were transferred to the Alder Hey Children's Hospital in 1994. Liverpool Community College Arts Centre has now been built on the site.

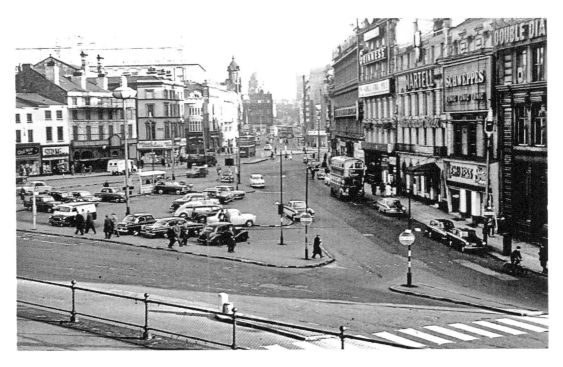

Along Lime Street

Lime Street, looking towards Renshaw Street from St George's Plateau. The hotels on the right were demolished to make way for the St John's Market and Shopping Centre. On the left a new approach and entrance to Lime Street Station has been provided.

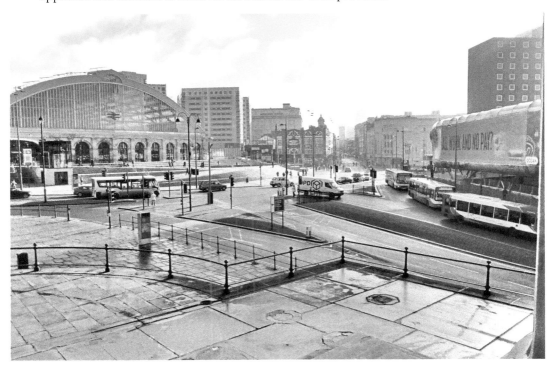

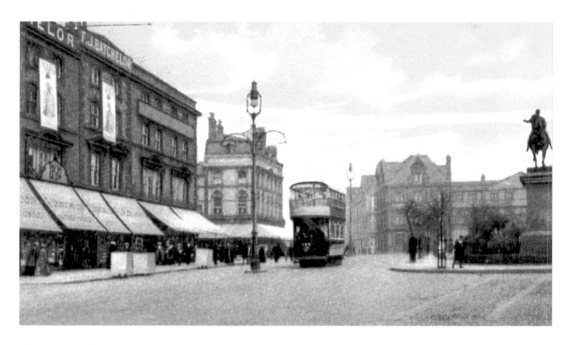

The Statue of George III

The top of London Road showing the statue of George III. It is a bronze equestrian figure in Roman dress, which was modelled by Sir R. Westmacott and was originally intended to be placed in Great George Square. However, it was decided to place the statue in its present position, and it was erected in 1822. An outdoor market is provided around the statue most of the year.

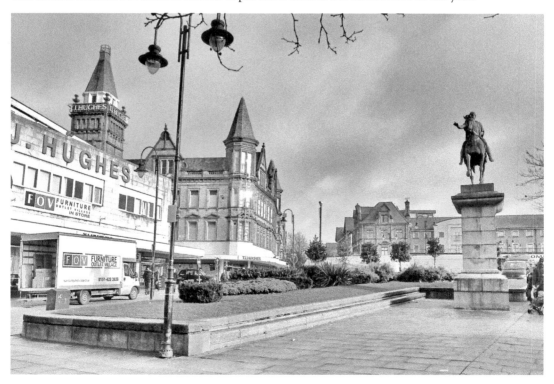

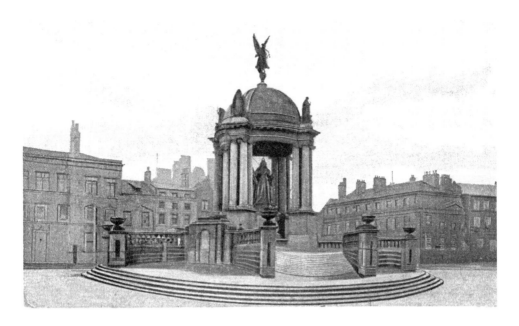

The Victoria Monument

The Victoria Monument was built in 1901 on the site of St George's Church, which was demolished in 1897. It was designed by F. M. Simpson, who was the first Professor of Architecture at the University of Liverpool. The four sections represent Agriculture, Commerce, Education and Industry. St George's church was built on the site of Liverpool Castle, which operated from 1235 to 1725. By 1347 the castle had four towers, and was surrounded by a dry moat; the castle included a chapel, bakehouse, brewhouse, herb garden and an orchard. The parliamentarian John Moore took possession of the castle during the Civil War and Parliament later ordered that the castle be demolished, but only parts were taken down. However, the castle was a ruin by the early 1700s. The monument was surrounded by bombed buildings during the Second World War, and the new Crown Court has now been build around it.

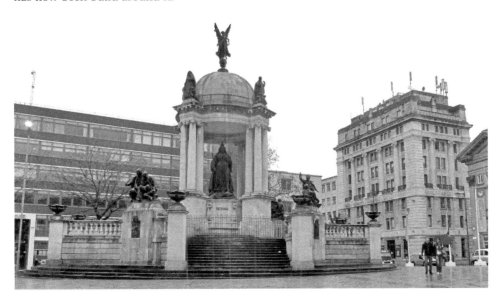

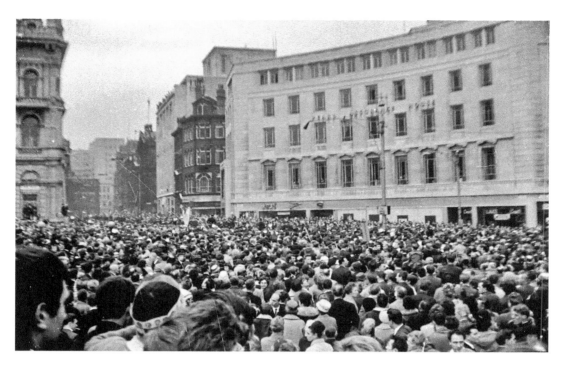

Crowds Await The Beatles
Crowds converge on Castle Street in the 1960s to witness the appearance of The Beatles on the balcony of the Town Hall.

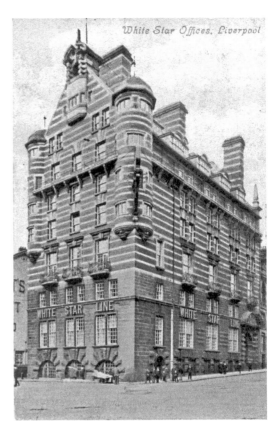

Albion House

Albion House was built in 1898 for Ismay, Imrie & Company, otherwise known as the White Star Line. It was designed by Norman Shaw and J. Francis Doyle. The building is at the corner of The Strand and James Street, and is constructed from white Portland stone and red brick. The main gable was damaged during the Second World War, but was repaired several years later.

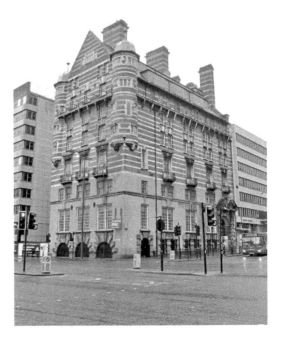

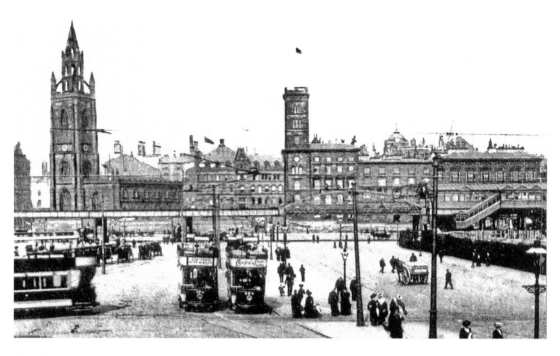

The Pier Head

The Pier Head, St Nicholas' church and the Overhead Railway. Construction of the foundations of the Royal Liver Building can be seen on the right of the photograph.

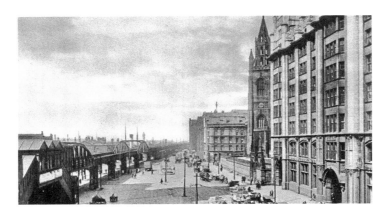

The Strand

The Strand, showing Tower Building and St Nicholas' church. Tower Building, completed in 1908, was designed by W. Aubrey Thomas and is one of the earliest steel-framed buildings built in the United Kingdom. It is finished with self-cleaning, white-glazed tiles and large windows to allow the maximum amount of light into the building. Sir John Stanley built the first tower in 1406, and during the eighteenth century the Tower of Liverpool, between Tower Gardens and Stringers Alley, was the main jail of Liverpool. It was used to house debtors and criminals. The Tower contained seven small underground dungeons, which housed between three and five prisoners in each, and there was a chapel in one of the rooms. In 1756, during the war with France, the Tower was used to house prisoners of that conflict. It became the property of the Corporation in 1775, when they purchased it from Sir Richard Clayton.

On 3 July 1811, all the prisoners were transferred to a new jail in Great Howard Street. The Tower was demolished in 1819 and replaced by warehouses, and by 1856 a second Tower Building containing offices was built on the site. This building was demolished only fifty years later. Tower Building was converted into apartments in 2006, with the two lower floors retained for commercial and retail use. It overlooks the Royal Liver Building built in 1910, which was also designed by W. Aubrey Thomas.

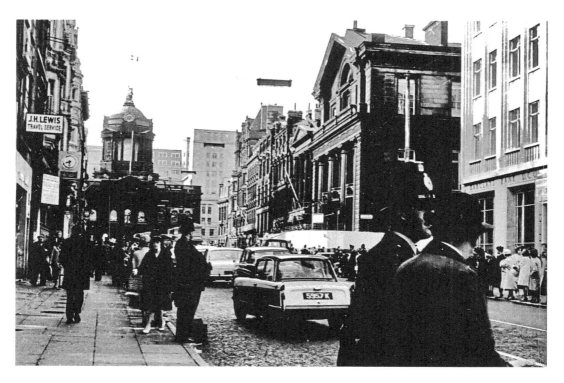

Castle Street

A busy lunchtime scene in Castle Street in the 1960s. Castle Street is the centre of the commercial, business and banking area of the city. The Bank of England building is in the centre of the photograph.

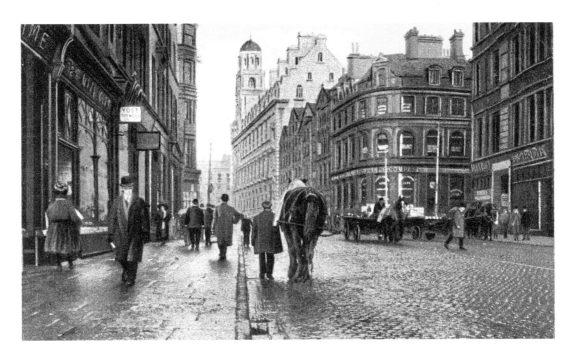

North John Street

A horse is led down North John Street towards Dale Street. The building with the dome in the centre of the picture is the Royal Insurance Building, which is on the corner of Dale Street and North John Street. It was built between 1897 and 1903, and was designed by J. Francis Doyle after a competition short-list of seven designs. It is built in granite and Portland stone over a steel frame.

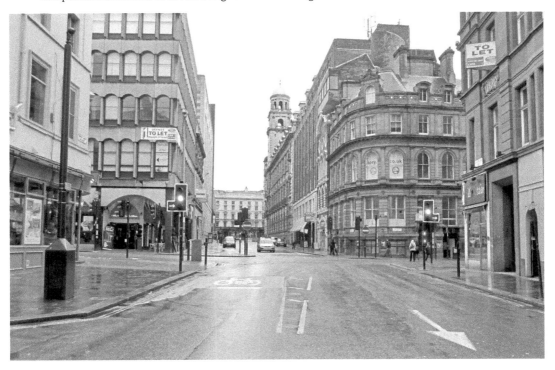

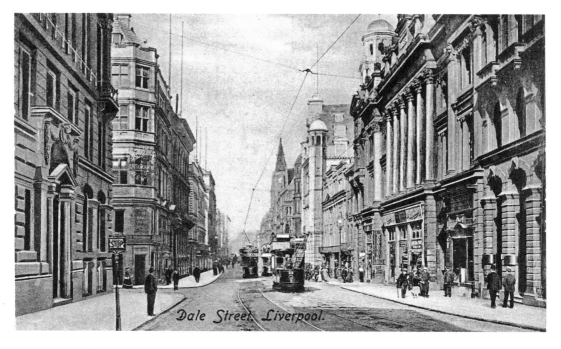

Dale Street, Liverpool.

Down Dale Street

Dale Street, looking from outside the Town Hall towards William Brown Street. Dale Street was originally the main route into the town from Manchester and London. There was a bridge over a brook at the east end of the street, and the road was widened in 1786. It was developed with buildings and office accommodation from the middle of the nineteenth century.

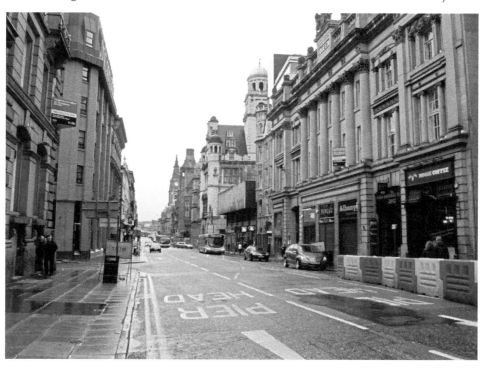

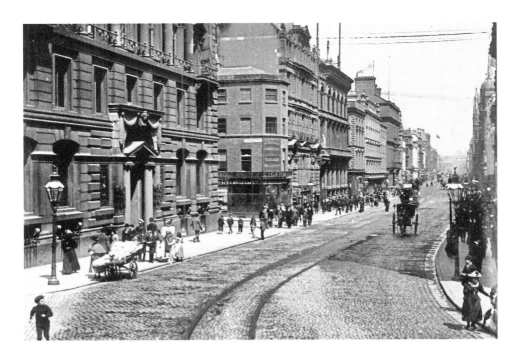

From Castle Street Along Dale Street

Another view looking up Dale Street from the northern end of Castle Street. The building on the left was built as the Liverpool and London and Globe Insurance Company between 1855 and 1857, and was designed by C. R. Cockerell. The Queen Insurance Building is opposite, and was designed by Samuel Rowland for the Royal Bank and was completed in 1839. A central passageway leads to Queen Avenue, a street lined with shops and offices. There is an underground passage which was used during the Second World War as a shelter.

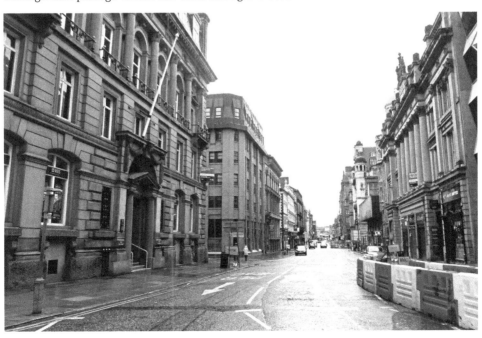

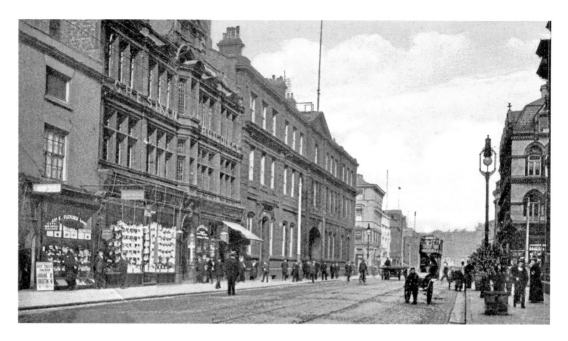

The Magistrates Court
The Magistrates Court at the top of Dale Street were built between 1857 and 1859, and designed by John Weightman. The juvenile courts are in the same complex, but are accessible from around the corner in Hatton Garden.

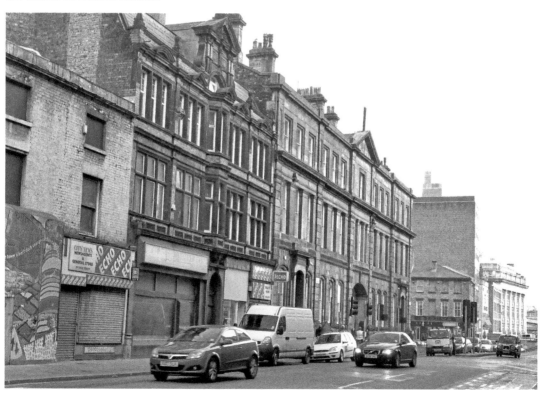

The Cotton Exchange

The Cotton Exchange in Old Hall Street was built between 1905 and 1906. The first American cotton to be shipped to Liverpool arrived at the port in 1784. Cotton was imported from Brazil, Egypt and India, and by 1850 cotton accounted for almost half the city's trade. Initially, the cotton merchants met on Exchange flags to sell and buy the commodity, and an Exchange was opened in 1808, but the merchants continued to deal in the square until the end of the nineteenth century. Old Hall Street was formerly White Acres Street or Peppard Street, and the seat of the Moores was originally called More Hall. When the Moore family moved to Bank Hall, they referred to More Hall as the Old Hall, and the street leading to it was then known as Old Hall Street.

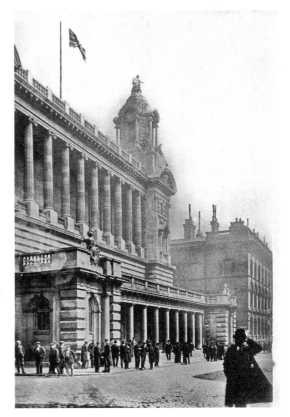

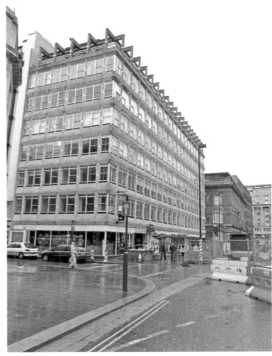

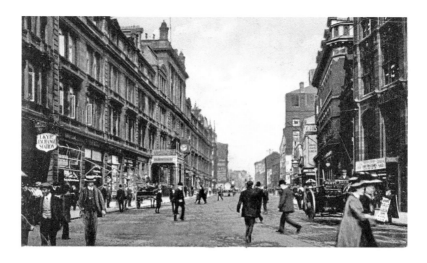

Exchange Station

Exchange Station was originally opened as Tithebarn Street Railway Station on 13 May 1850, and was rebuilt between 1886 and 1888 and renamed Liverpool Exchange on 2 July 1888. The station was the terminus of the Lancashire & Yorkshire Railway, providing services to Manchester Victoria, Blackpool North and the Lake District, Whitehaven and Glasgow Central. In March 1904, steam was replaced by electric trains on the route to Southport, with the route to Ormskirk being electrified in 1911. The station was damaged by bombing during the war, and on 3 August 1968 the last British Rail scheduled passenger train to be hauled by a standard gauge steam locomotive finished its journey at Liverpool Exchange. Long-distance services were transferred to Lime Street Station in the 1960s, and in the 1970s the local trains were diverted via a new tunnel to Liverpool Central and the south of the city. The main station was closed on 30 April 1977, and Moorfields Station opened the following week to provide services by Merseyrail. The station was later demolished, leaving the frontage to be incorporated into a new office building called Mercury Court.

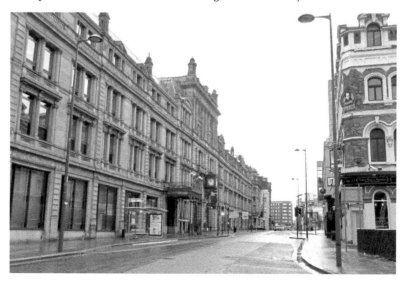

The Tramways

At the beginning of the twentieth century, it was intended to build the head office for the trams on reclaimed land at Georges Dock. However, Hatton Garden, near the Central Police Station, the Central Fire Station and the Fire Salvage Association, was purchased. The site was originally owned by John Gordon Houghton, and was bought by the Corporation on 20 July 1904. The foundation stone for No. 24 Hatton Garden was laid on 12 September 1905 by the Chairman of the Tramways Committee, Sir Charles Petrie, and the building was completed in January 1907 at a cost of £48,650. The official opening of the building took place in August that year when the new Chairman of the Tramways Committee, Alderman Fred Smith, received a golden key, the Lord Mayor, Richard Caton, received a silver rose bowl and the Corporation Surveyor, Thomas Shelmerdine, a silver cup. The Committees for the Corporation Tramways and Electric Supply Department merged in January 1906, and the Electric Supply Department's central staff and cash offices moved into the building. On 30 June 1985, the building was given Grade II Listed Building status, and on 26 October 1986 public transport was deregulated, and it became the headquarters for the Merseyside Passenger Transport Executive.

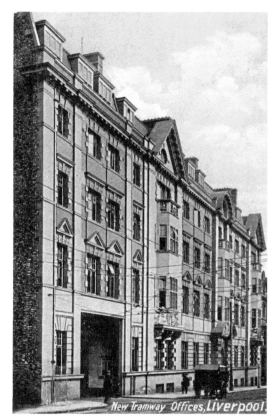

New Tramway Offices, Liverpool.

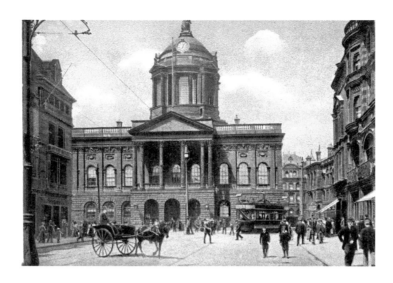

Liverpool Town Hall

Liverpool Town Hall in Castle Street is the city's third, and was designed by John Wood of Bath. It was built between 1749 and 1754, and an extension to the north, designed by James Wyatt, was added in 1785. A serious fire severely damaged the hall in 1795, and it was rebuilt with a dome added, the work being completed in 1802. A central courtyard was replaced with a hall containing a staircase, a portico was added to the south side and the work, including the decoration, was completed by 1820. In 1775, during a dispute with their employers, who were inside, seaman attacked the building with a cannon, and in 1881 there were attempts made to blow up the building. The ground floor was designed to allow merchants to undertake their business, and it now contains the Council Chamber and a Hall of Remembrance for Liverpool servicemen who died in the First World War. The building was also damaged by bombing and air raids during the Second World War. A restoration programme of work was completed in 1995.

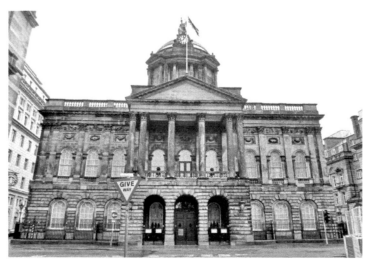

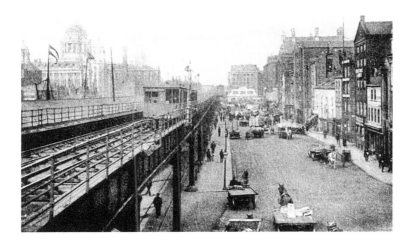

Liverpool Overhead Railway

The Liverpool Overhead Railway passes Canning Dock. The railway was the world's first electrically-operated overhead railway, and ran from Dingle to Seaforth along the Dock Road. It was opened on 4 February 1893 by the Marquis of Salisbury and ran for six miles from Alexandra Dock to Herculaneum, with eleven stations along the line. It was extended to Seaforth Sands on 30 April 1894, and to Dingle on 21 December 1896. A northward extension was completed in 1905 which took the line to the tracks to the Lancashire & Yorkshire Railway's North Mersey Branch, and this allowed a service to be provided to Aintree Racecourse when the Grand National Race took place. Following the end of the war, various surveys were carried out which found that the track and structure were badly corroded, and that it would be very expensive to repair the system. Consequently, the Liverpool Overhead Railway Company went into voluntary liquidation, and the line closed on 30 December 1956. Work to completely demolish the line commenced in 1957, and was completed the following year.

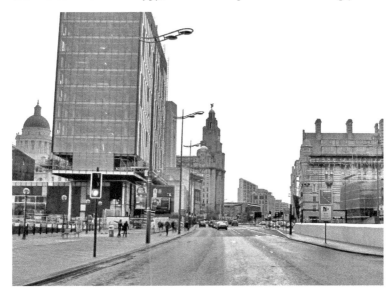

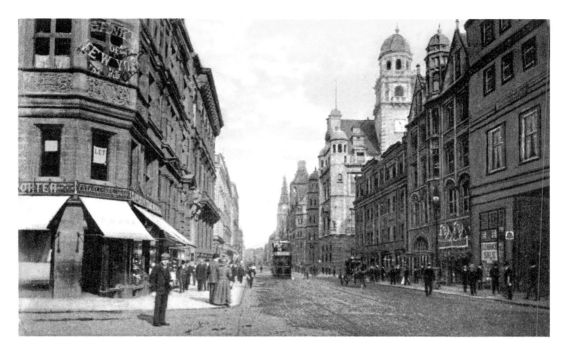

Towards the Municipal Buildings

Dale Street, looking up from the Town Hall towards the Municipal Buildings. The Royal Insurance Building with its distinctive dome can be seen on the corner of North John Street. Dale Street got its name from the dale through which flowed the stream from Moss Lake to the Pool of Liverpool. It was one of the original seven streets.

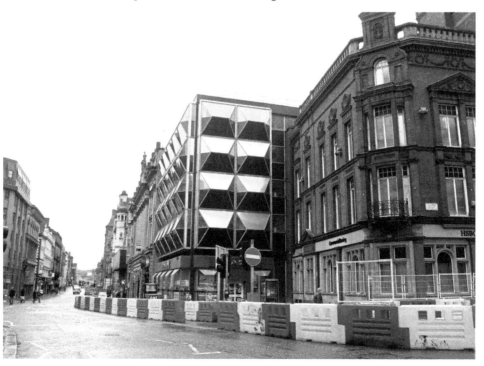

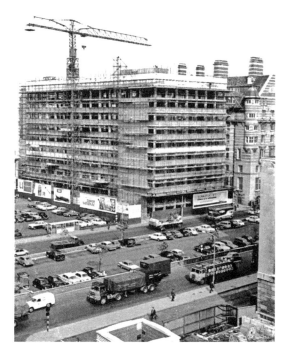

Beetham Plaza
The Strand next to Albion House was developed in the 1960s. The building on the left is Beetham Plaza, which was constructed as an office building and has now been converted to provide forty-five luxury apartments and penthouses. It also includes some office accommodation, a restaurant and a public square.

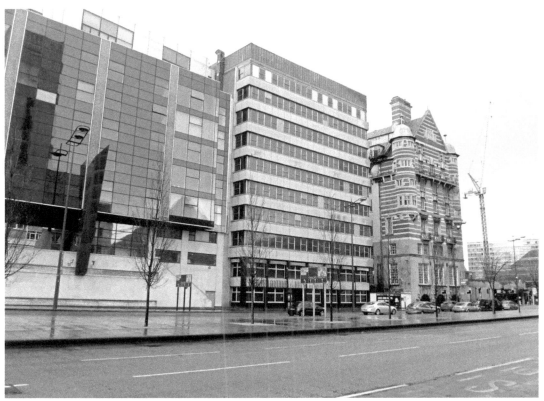

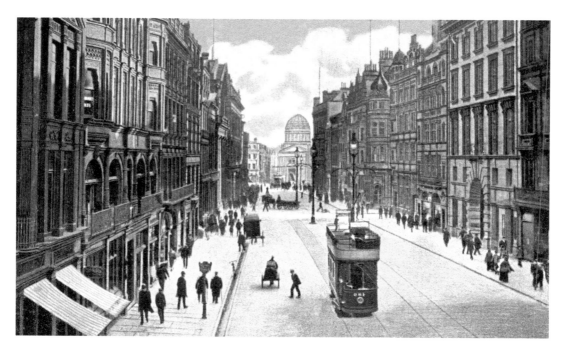

From Castle Street to the Victoria Monument

Castle Street, looking toward the Victoria Monument. The building on the right is the National Westminster Bank, which was designed by Norman Shaw and completed in 1902. The Sanctuary Stone in the road surface outside the bank is the mark of the boundary of the old Liverpool Fair, held each year on 25 July and 11 November. In this area, for ten days before and after each fair, debtors were able to walk free from arrest, providing they were on lawful business.

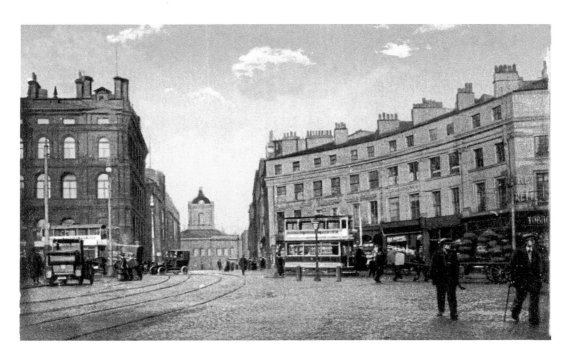

From the Victoria Monument

Looking down Castle Street from the Victoria Monument.

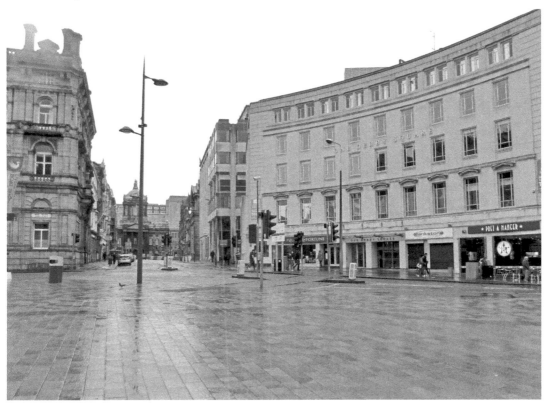

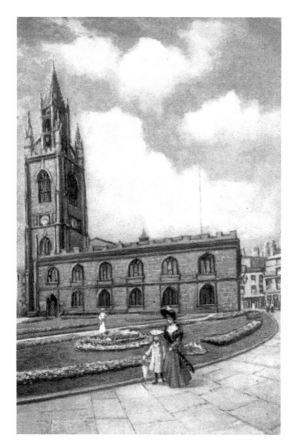

The Sailors' Church

The Church of Our Lady and St Nicholas is frequently referred to as the Sailors' Church. St Mary del Quay was a small place of worship that stood on the site in the middle of the thirteenth century until a new chapel was built, nearly one hundred years later. This was dedicated to St Mary and St Nicholas, and when a plague hit the town in 1361 it was licensed as a burial ground. The chapel was extended in the fifteenth century, and by 1515 the church contained four chantry altars. The church was used to detain prisoners during the Civil War years, and between 1673 and 1718 the building was extended; a spire was added in 1746. At the beginning of the eighteenth century, when Liverpool became an independent parish, St Nicholas' and St Peter's became the parish churches. The church was extended again in 1775. On 11 February 1810, twenty five people were killed, including seventeen young girls from the Mossfields Charity School, when the spire of the church collapsed. A new tower, designed by Thomas Harrison of Chester, was built between 1811 and 1815. The last burials in the graveyard took place in 1849, which it became a public garden dedicated to James Harrison, whose shipping line office was situated to the rear of the church. A Deed of Faculty was granted in 1892 to allow the laying out of the graveyard as an ornamental ground, and a Parish Centre was built in the 1920s. The church was severely damaged in the blitz of December 1940, and following extensive rebuilding it was consecrated again on 18 October 1952.

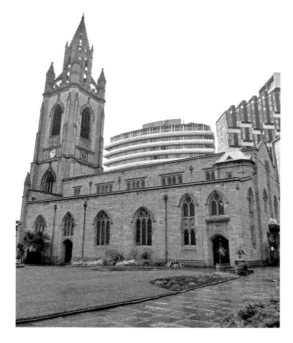

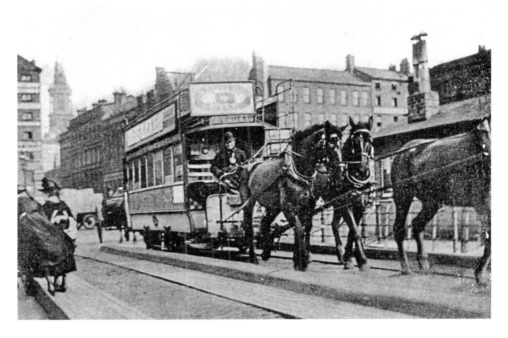

The Strand and Water Street

A horse tram crosses The Strand at the bottom of Water Street. Strand Street was originally the shore of the river between high and low water. In the 1850s, the buildings in Strand Street between Redcross Street and Crooked Lane had so many sailmakers that it came to be called 'the Sailmaker's Home'.

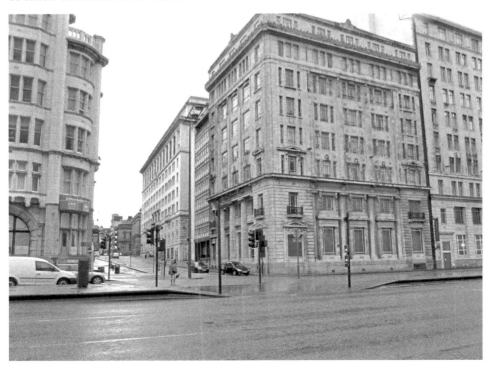

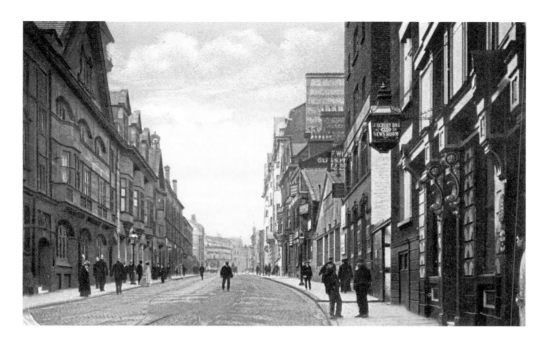

Hatton Garden

Looking up Hatton Garden, with the City Transport offices on the right and the Fire Station on the left-hand side of the road. This was built in 1898, and both buildings were designed by Thomas Shelmerdine, who was the Corporation Surveyor. The Main Bridewell and courtyard is situated behind the City Magistrates Court, at the Dale Street end of the road. Hatton Garden was named after Hatton, near Warrington, the native village of the Johnson brothers, who originally owned the land.

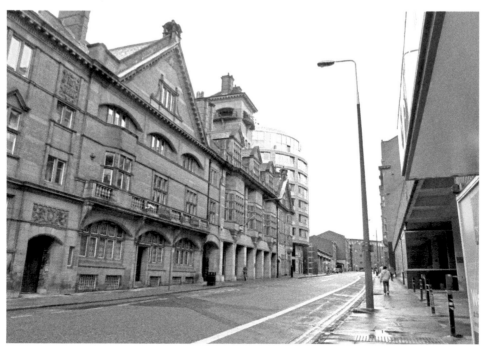

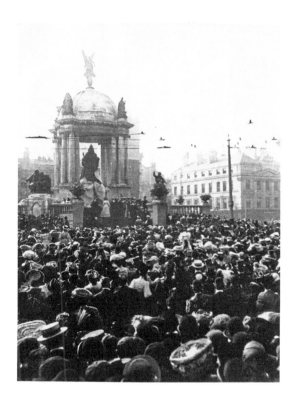

Derby Square

The Victoria Monument in Derby Square
was unveiled in 1902. Derby Square was
named after Lord Derby, who obtained
a small grant to enable a small square
to be formed for a market on the site of
Liverpool Castle.

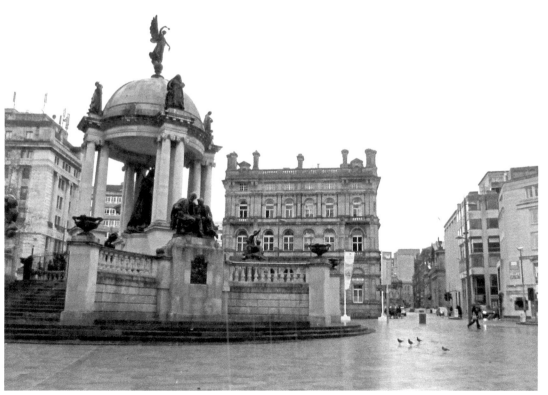

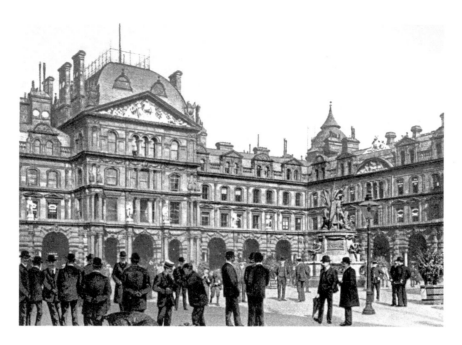

Exchange Flags

Exchange Flags is at the back of the Town Hall and contains the Nelson Monument, which was designed by Matthew Cotes Wyatt and sculpted by Richard Westmacott. It was unveiled in 1813. The first building was replaced by a new exchange in 1862, designed by T. H. Wyatt, and the present Exchange Flags dates from 1939. Sir Winston Churchill moved the headquarters of the Central Operations from Plymouth to Exchange Flags in Liverpool in 1941. The combined services were able to control the Western Approaches from this centre.

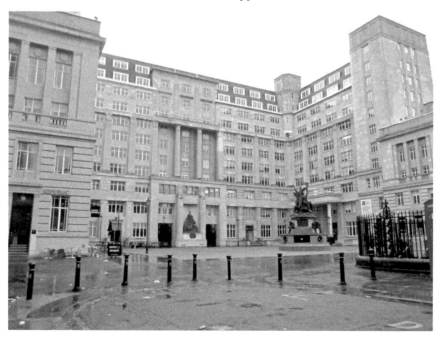

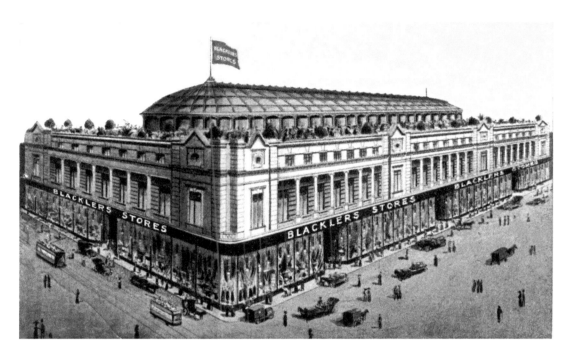

Blacklers Department Store

Blacklers department store was situated on the corner of Elliot Street and Great Charlotte Street. It was founded by Richard Blackler and A. B. Wallis in the early twentieth century. When the building was damaged in May 1941, the company operated from premises in Church Street and Bold Street. The store reopened in 1953, and operated until its closure in 1988. Various outlets now operate from the premises.

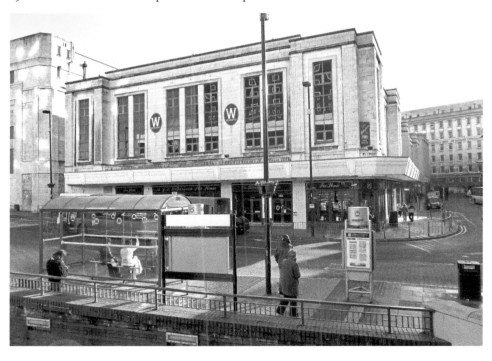

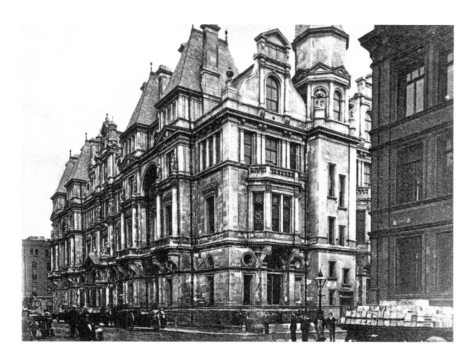

The General Post Office

The front of the General Post Office in Victoria Street. Victoria Street was named after Queen Victoria, and was laid out in the 1860s to provide a new approach to Lime Street Station and St George's Hall. The Post Office was designed by Henry Tanner to resemble a Loire chateau, and constructed between 1894 and 1899 with sculpture by Edward O. Griffith around the main entrance. The upper floors were severely damaged during the Second World War, and were removed. The building has now been converted into a shopping centre.

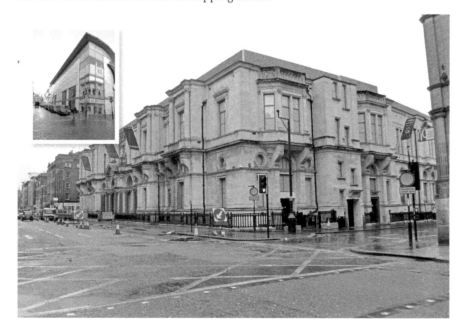

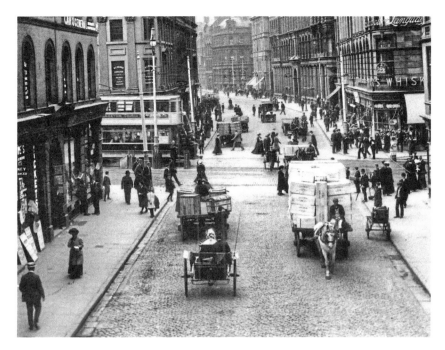

North John Street, South John Street and Lord John Street

The junction of North John Street, South John Street and Lord Street. North John Street was formerly known as Saint John Street, from lands belonging to the chantry of Saint John in the Church of Our Lady and Saint Nicholas. South John Street now forms part of the Liverpool One shopping area, and was formerly known as Trafford's Weint, after Henry Trafford, mayor in 1740. The horse-drawn carriage in the bottom photograph provides a service for people travelling around the city centre.

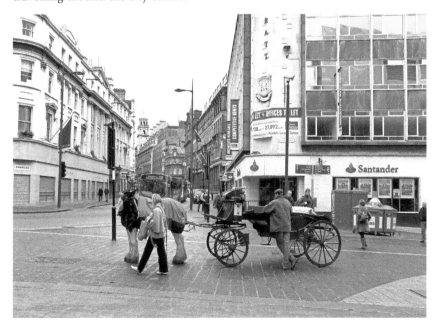

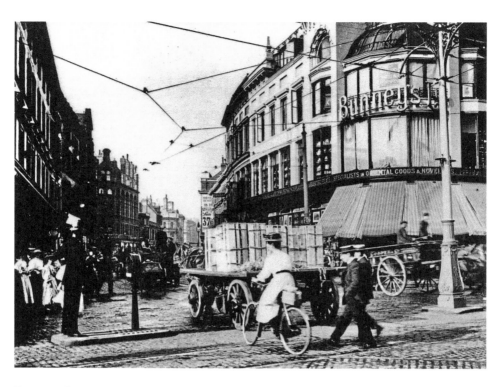

Bunneys Store

Bunneys Store, 'Specialists in Oriental Goods and Novelties', on the corner of Whitechapel and Church Street.

Central Station

Central Station in Ranelagh Street was opened on 2 March 1874, and was the terminus of the Cheshire Lines Committee route to Manchester Central. There were six platforms on the mainline station, providing services to London St Pancras, Hull, Harwich, Stockport, Southport and London Marylebone. Most services were transferred to Lime Street Station in 1966, and the local services that remained were closed on 17 April 1972. The high-level station was demolished the following year, becoming a car park for several years. There are plans to develop this area into a Central Village, comprising retail and residential units. Services to West Kirby, Rock Ferry, New Brighton and Hunts Cross were provided from Liverpool Central low-level station, and a loop line now links the Wirral Line with Moorfields, Lime Street, Central and James Street Stations. The line from Southport continues to Hunts Cross via Central Station.

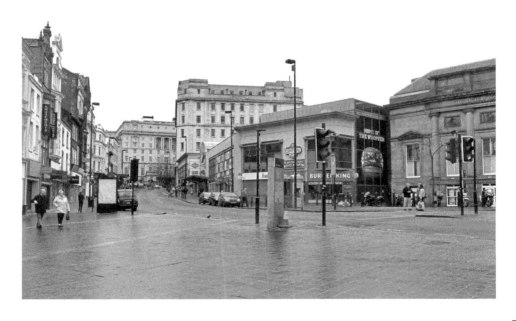

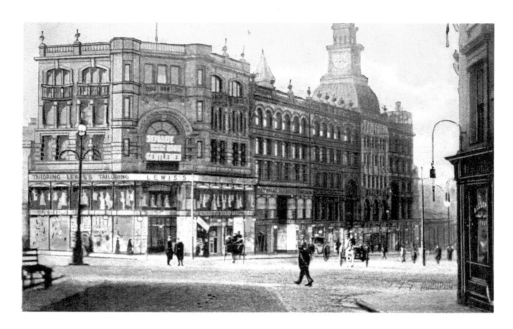

David Lewis

David Lewis opened his first store in 1856 selling men's and boy's clothing, and women's clothing from 1864. He added shoes in 1874 and tobacco in 1879, and a Christmas Grotto in 1879. A store was opened in Manchester in 1877, and another in Birmingham in 1885. The store in Sheffield was opened in 1884, but was closed four years later. When Louis Cohen took over the business, new stores were opened in Glasgow, Leeds, Hanley, Leicester and Blackpool. However, the company went into administration in 1991 and several stores were purchased by Owen Owen Limited. The last store to operate was at Liverpool, but the company went into administration in 2007 and the store was sold to Vergo Retail Limited. This store continued to trade, but it was announced that it would finally close on 29 May 2010.

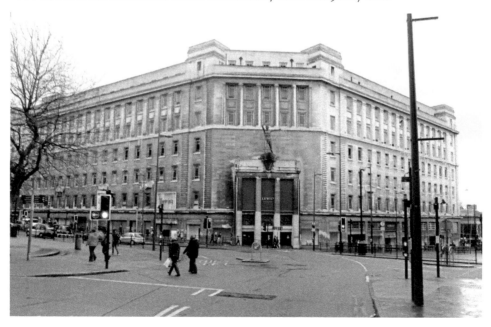

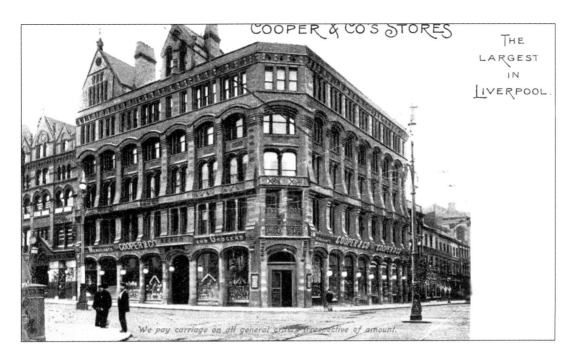

Coopers Store

Coopers Store in Church Street was one of the most popular food shops in the city centre. It was famous for the aroma of the different types of coffee it sold and the variety of different kinds of bread that was freshly baked each day.

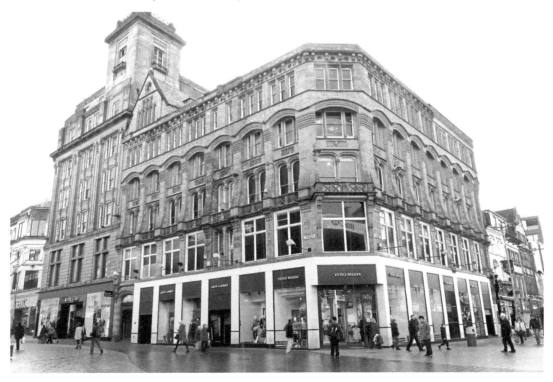

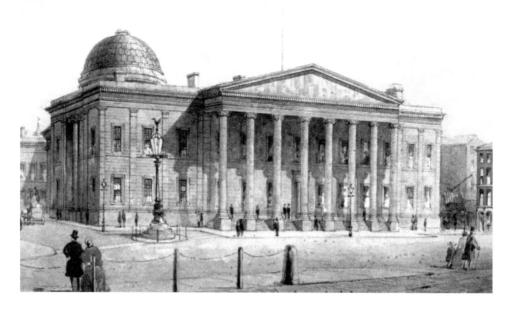

The Customs House

The Customs House was built between 1828 and 1839, and was designed by John Foster on the site of the Old Dock. It incorporated a post office and offices for the Mersey Docks and Harbour Board. The Custom House was bombed in the May 1941 blitz, and was demolished in 1948. It was built opposite the entrance to Albert Dock and now forms part of the Liverpool One development.

The Municipal Buildings

The Municipal Buildings in Dale Street was built in between 1860 and 1866, and was designed by John Weightman, who was the Corporation Surveyor. It was completed by Weightman's successor, E. R. Robson, and contains a mixture of Italian and French Renaissance styles. The Municipal Annexe, situated next to the Municipal Buildings, was built in 1883, and was designed by F. & G. Holme.

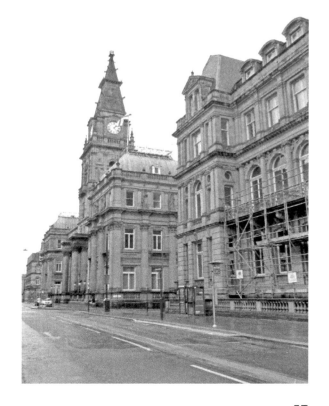

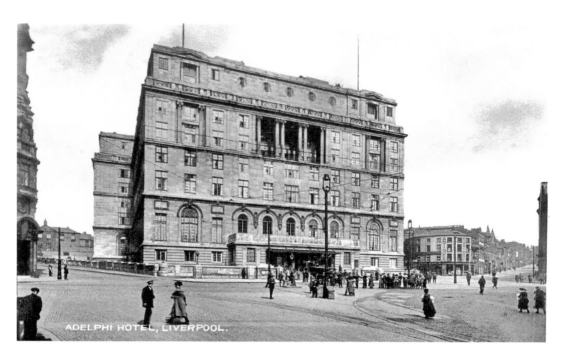

ADELPHI HOTEL, LIVERPOOL.

The Adelphi Hotel

The original Adelphi Hotel, built on the site in Ranelagh Street, was completed in 1826, and the present hotel in 1914. It is Liverpool's largest hotel and contains two restaurants, two bars, a pizzeria, a gymnasium, a Jacuzzi, steam room sauna, solarium and a heated marble swimming pool. It was purchased by Britannia Hotels Limited in 1982.

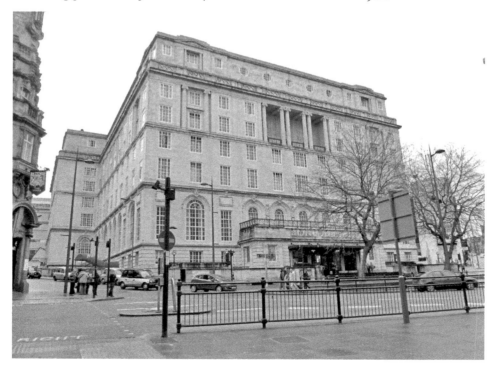

Liverpool Cathedral

The Anglican Cathedral is the largest in the United Kingdom and the fifth largest in the world, and is built on St James' Mount. The official name is the Cathedral Church of Christ in Liverpool, and it is dedicated to Christ and the Blessed Virgin. The first Bishop of Liverpool was the Rt Revd John Charles Ryle, who was installed in 1880 when the city did not have a cathedral, only the parish church of St Peter's. A competition to design a new cathedral attracted over 100 entries, and Giles Gilbert Scott's design was chosen with George F. Bodley to oversee the detailed architectural design and building work. The foundation stone was laid by King Edward VII in 1904, and the Lady Chapel was opened in 1910. The original design was altered to incorporate a single tower, and the church was consecrated in 1924. The tower was completed in 1942, and work continued until the building was finished in 1978. However, Scott died in 1960 and did not see his work completed.

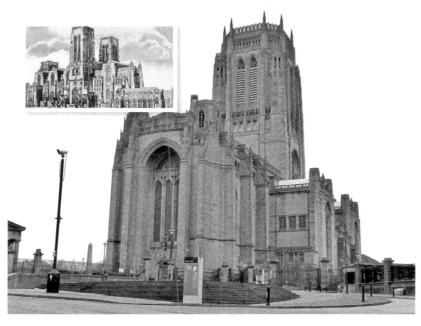

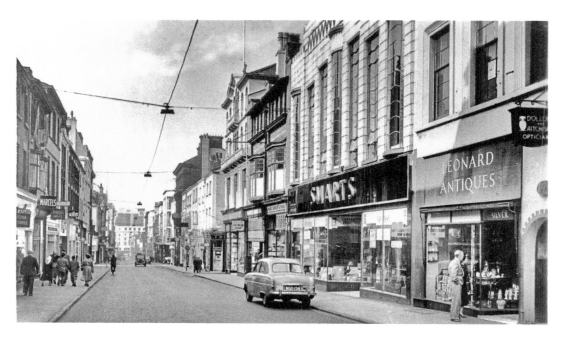

Bold Street

A dramatic contrast of traffic; a single vehicle is parked outside Smarts' store in Bold Street, compared to the view taken in 2011. Bold Street was named after Jonas Bold, who leased land from the Corporation on which St Luke's Church and a ropery, owned by James and Jonathon Brookes, were built.

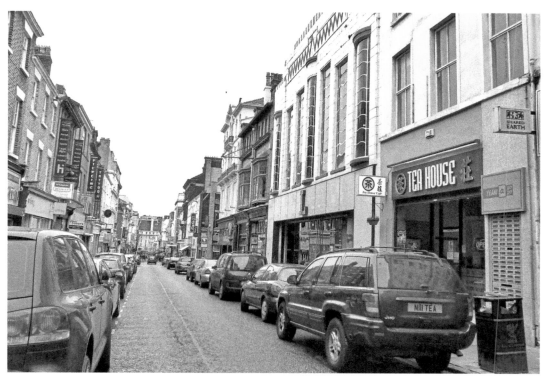

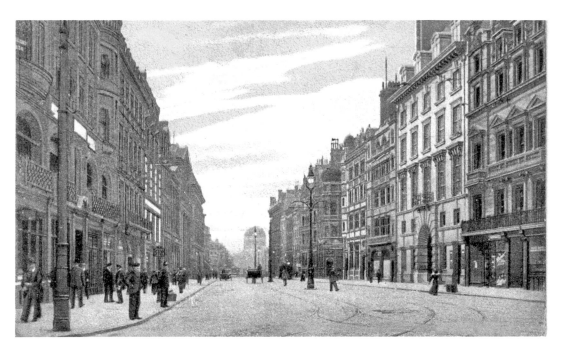

From Castle Street to the Customs House
Looking down Castle Street, from outside the Town Hall towards the Customs House.

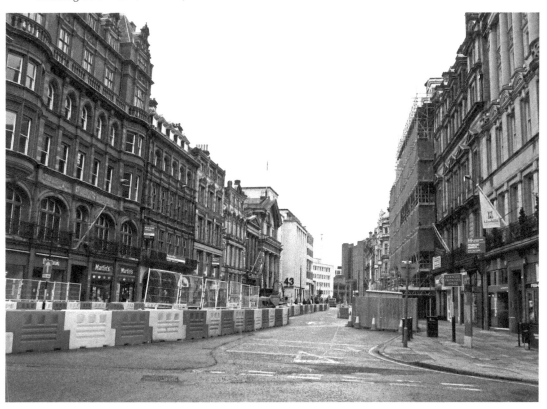

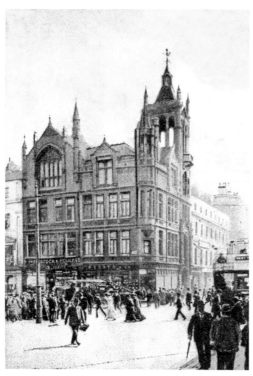

Church House
Church House was located in South Castle
Street, which now forms part of the new
Liverpool One shopping development.

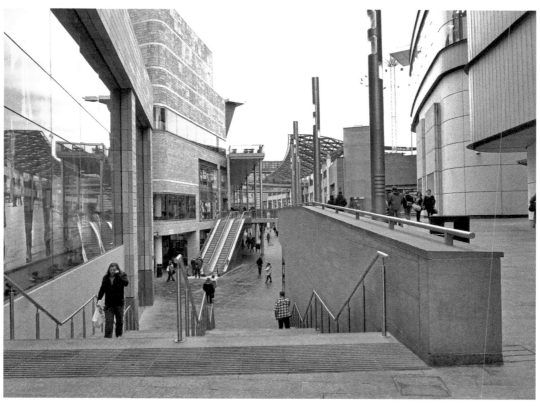

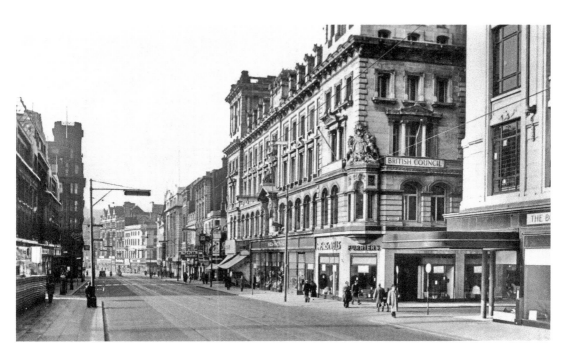

From Bold Street Along Church Street
Looking down Church Street shopping centre from the bottom of Bold Street.

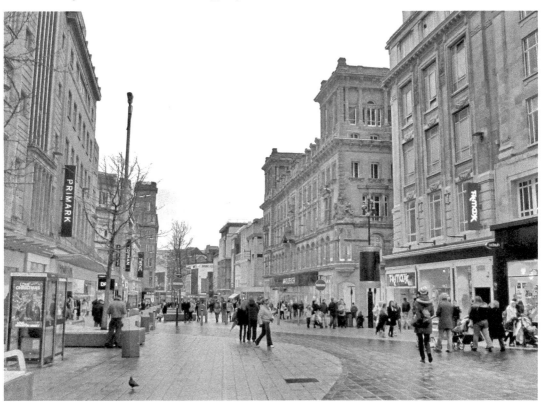

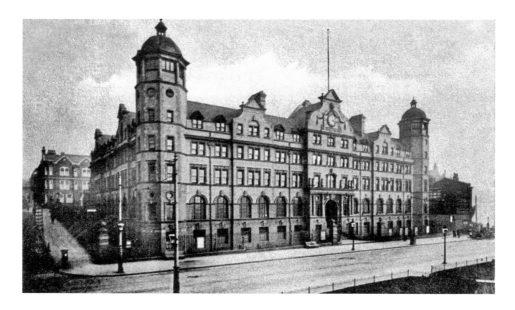

The David Lewis Hostel

David Lewis was a successful businessman who opened a shop in Liverpool in 1856, and a major retail store in Manchester in 1880. When he died in 1885, he willed that his money be used for the benefit of the working-class people of Liverpool and Manchester. The David Lewis Trust was formed on 7 July 1893, and a centre providing residential facilities for people suffering from epilepsy was established by the Manchester trust. The David Lewis Theatre was established in 1906, and was used as a music hall and club. Films were shown to school children in the 1920s, a boxing licence was obtained and billiards was introduced in the 1930s. The theatre could accommodate 1,000 people, and two sound projectors were installed in 1936. Theatre productions continued up to the 1960s. However, the complex was closed at the end of November 1977, and the building was demolished in 1980.

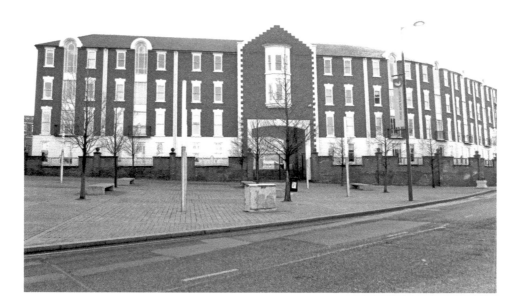

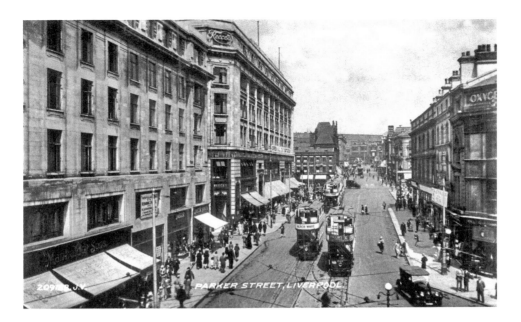

Parker Street

Parker Street, with the department store Owen Owen in the centre of the photograph. The first Owen Owen store was opened in London Road, and later moved into the Parker Street premises on Clayton Square. Another store was opened in Coventry, and when the firm took over T. J. Hughes, they moved them into the London Road premises. The Owen family sold the business in the 1980s, and the Parker Street store is now operating as a Tesco Metro and TK Maxx stores.

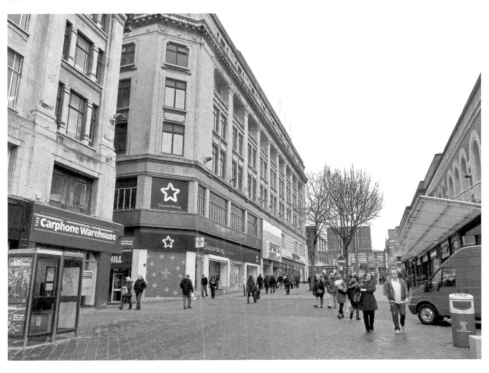

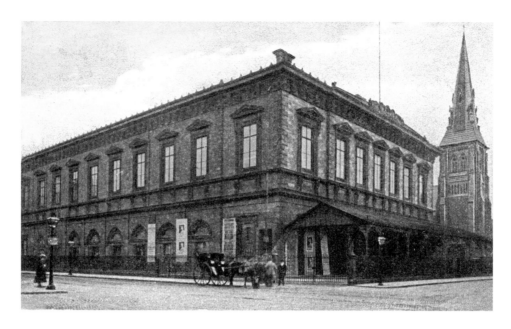

Philharmonic Hall

The Liverpool Philharmonic Society was formed in 1840, and John Cunningham prepared plans for a concert hall in 1844. The foundation stone of the hall was laid in 1846, and it was completed in 1849 at a cost of £30,000. On 5 July 1933 the hall was destroyed by fire, and Herbert J. Rowse was commissioned to design a new hall to be built on the same site. The new Philharmonic Hall was opened on 19 June 1939, with a concert conducted by Sir Thomas Beecham. The Hall received a substantial refurbishment in 1995, and it now stages around 250 events each year.

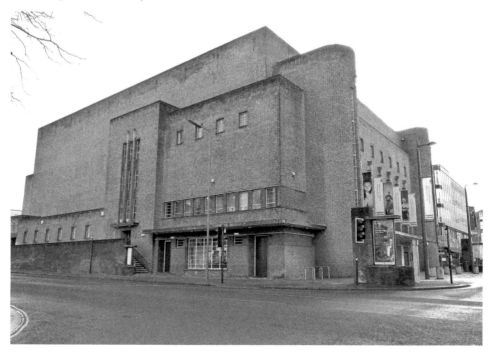

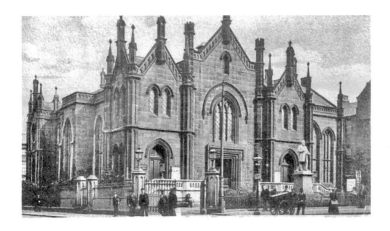

Myrtle Street Baptist Chapel

Stowell Brown's Myrtle Street Baptist Chapel. Hugh Stowell Brown was a Christian minister and preacher in Liverpool. He was born on 10 August 1823 in Douglas, Isle of Man, and was the son of an Anglican vicar. He left the Isle of Man in 1839 to take up an apprenticeship in land surveying in Birmingham. However, in 1840 he moved to Wolverton and became a teetotaller and a Sunday school teacher. Three years later, he was at college back in the Isle of Man, as he had decided to become an Anglican vicar. In 1847 he was in Liverpool, preaching at the Myrtle Street Baptist Chapel, and by 1851 he was speaking at Sunday afternoon sessions at St George's Hall. He helped to develop the Workman's Bank for the poor of the city, and became the President of the Baptist Union of Great Britain in 1878, Chairman of the Liverpool Seaman's Friendly Society and President of the Liverpool Branch of the Peace Society. When he died in 1886, there were more than ten thousand people lining the streets along the route of his funeral. In 1939, the Myrtle Street Church was closed and later demolished. A large part of Myrtle Street has recently been demolished, and is being developed as an extension to the University of Liverpool.

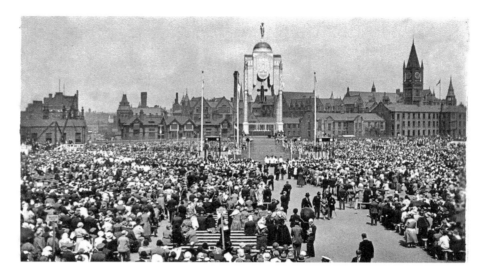

The Metropolitan Cathedral

Sir Edwin Lutyens was commissioned to design a cathedral, and he produced a design of a building that would have been the second largest church in the world. Work began on 5 June 1933, but it was suspended during the Second World War and it was decided not to continue with the original design. The crypt of the Metropolitan Cathedral was opened in 1958 by Archbishop Heenan, who invited applications for the design of a new cathedral. Sir Frederick Gibberd was the successful architect who produced the design for the modern circular building. Work commenced in 1962, using Lutyen's crypt as a platform and incorporating a large piazza where mass can be held outdoors. The concrete tower is 290 feet high, and is surmounted by a crown of thorns. The Cathedral was consecrated on 14 May 1967.

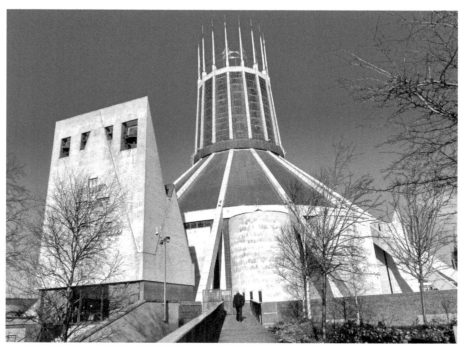

Along Lime Street
Lime Street, looking up towards Renshaw Street and St Luke's Church from St George's Plateau.

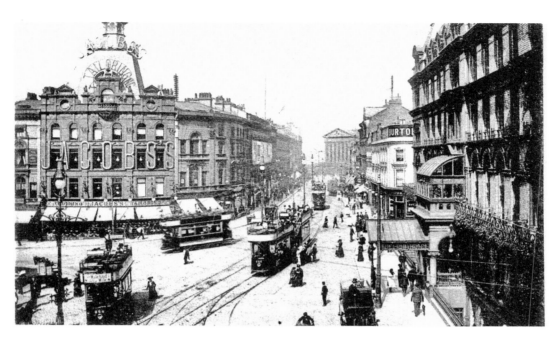

From St Luke's Church

Looking down Renshaw Street from the steps of St Luke's church.

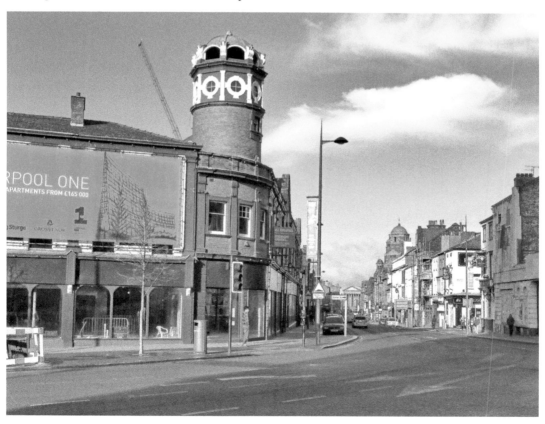

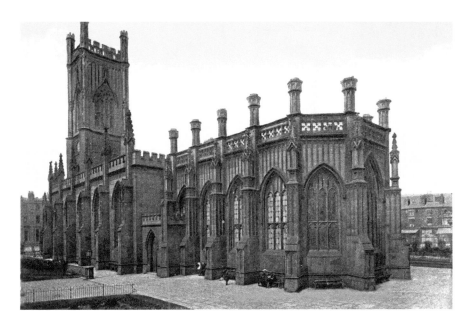

St Luke's Church

St Luke's church is situated on the corner of Leece Street and Berry Street. It was designed by John Foster, Senior, the City Surveyor, and built by his son John Foster, Junior, between 1811 and 1831, in the Gothic style. It was consecrated on 12 January 1831. The church was hit by an incendiary bomb on 5 May 1941, and was almost completely destroyed. Local residents who were sheltering during the air raid reported that they heard the great bell fall from the tower. It was bought by the Corporation in 1968, who decided to leave the shell as a memorial. The churchyard is now a public park, usually referred to as 'the bombed-out church'.

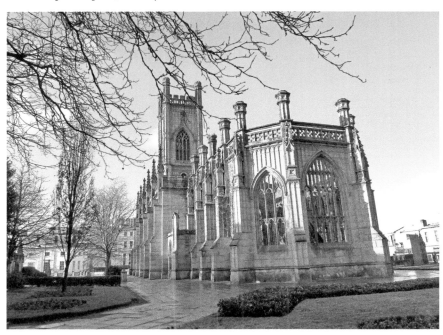

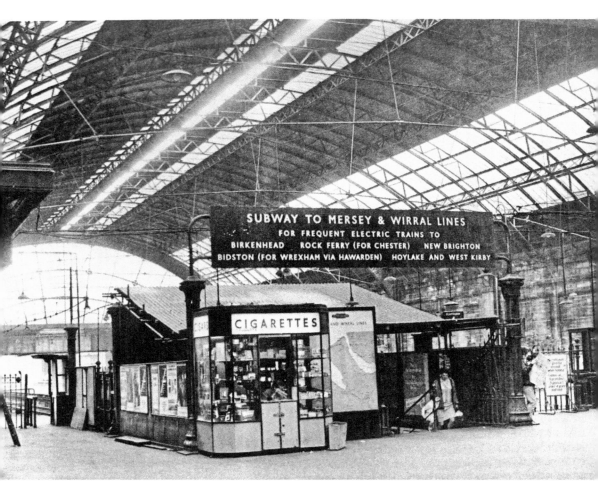

Liverpool Central Station
Liverpool Central High Level Station.

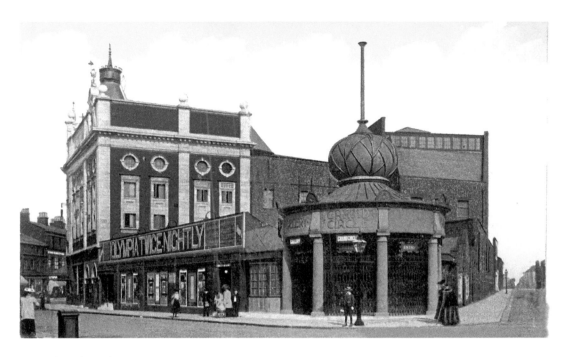

The Olympia

The Olympia in West Derby Road was built in 1905 for Moss Empires Limited and designed by the theatre architect Frank Matcham. It was originally intended to be a circus venue; the auditorium was built on four levels, and the stalls and balconies could accommodate 3,750 people. The stage had a 48-foot-wide proscenium, was 41 feet deep and had a height of 68 feet. It was converted into a cinema in 1925, and was used as a Naval Depot during the Second World War. It is now a Grade II Listed building and used as a nightclub and bar.

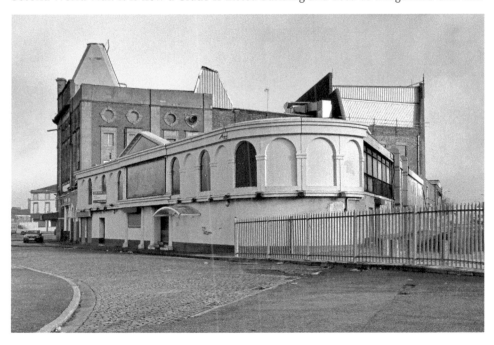

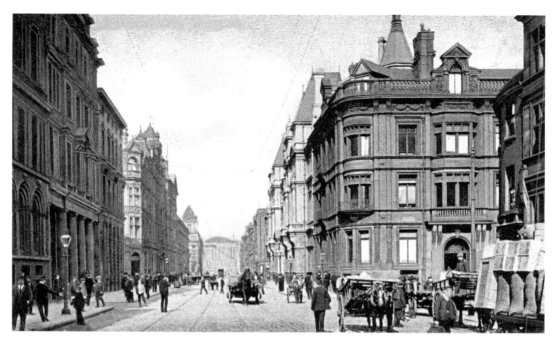

Victoria Street looking towards William Brown Street.

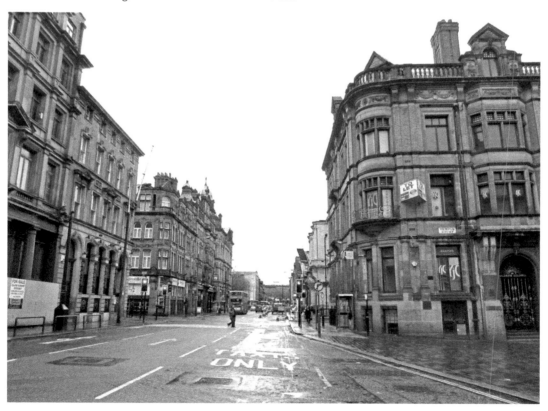

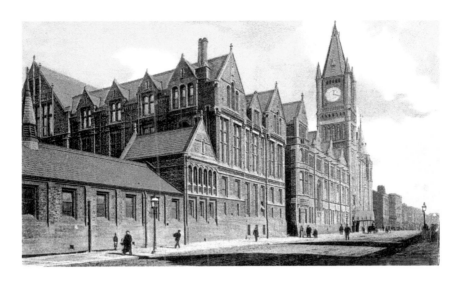

The Victoria Building

The Victoria Building was completed between 1887 and 1892, and was designed by Alfred Waterhouse to house University College before it became the University of Liverpool. It is situated on the corner of Brownlow Hill and Ashton Street, and was built with accommodation for administration and teaching, and also incorporates common rooms and a library. The building was the inspiration for the term 'red-brick university' used by Professor Edgar Allison Peers, and was converted to a museum and gallery in 2008. University College, Liverpool was established in 1881, and the Liverpool University Press was founded in 1899. A Royal Charter and Act of Parliament in 1903 enabled it to change its name to the University of Liverpool and confer its own degrees. In 1994, it was a founding member of the Russell Group, which is a collaboration of twenty leading research-intensive universities, as well as a founding member of the N8 Group in 2004.

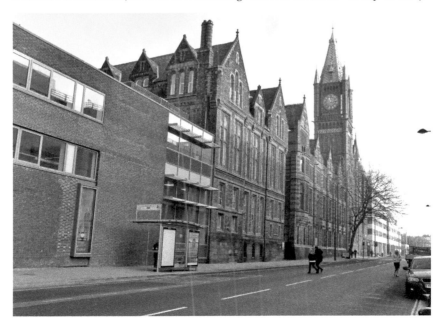

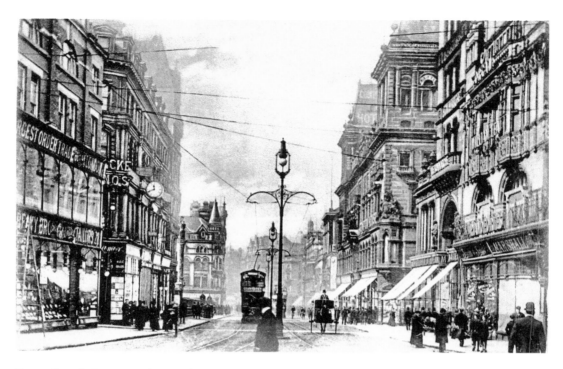

From Church Street to Liverpool Central Station
A tram and a horse-drawn carriage drive up Church Street towards Liverpool Central Station.

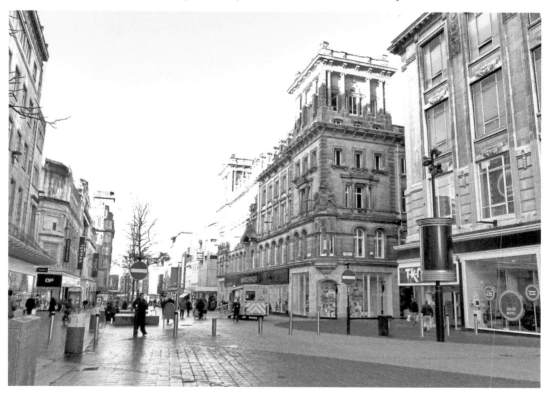

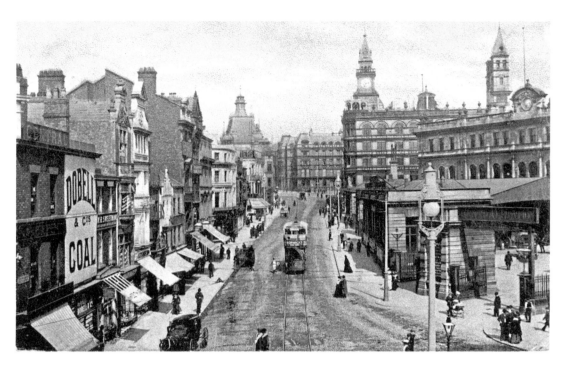

From Ranelagh Street to the Adelphi
Looking up Ranelagh Street towards the Adelphi Hotel in Renshaw Street.

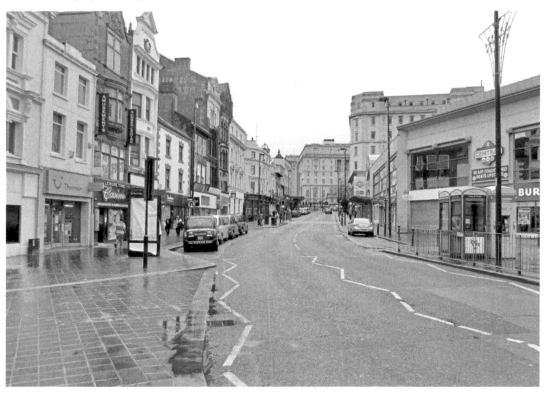

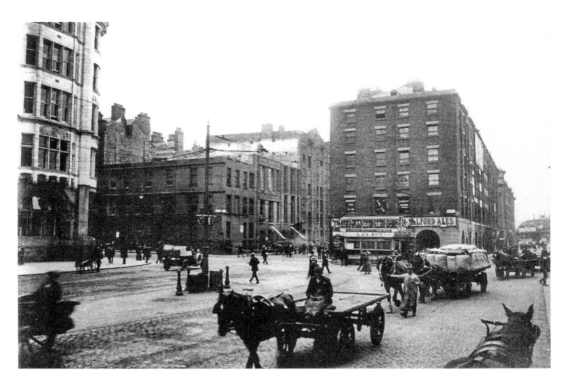

The Goree Plaza

A busy scene on the Goree Plaza on 16 July 1913. The corner of Tower Building can be seen on the left of both photographs, but the whole area has been changed completely by air raids and bombing in the Second World War, and the demolition of some of the buildings.

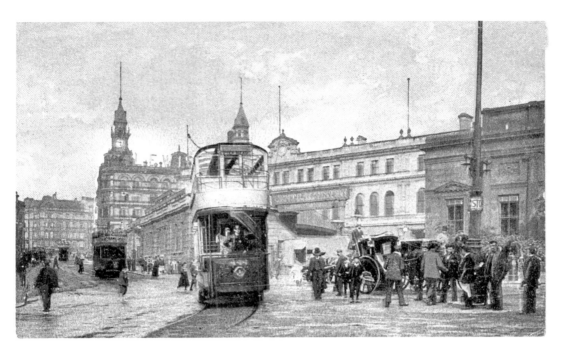

From Ranelagh Street Towards the Adelphi
Looking up Ranelagh Street towards the Adelphi Hotel and Lewis's Department Store.

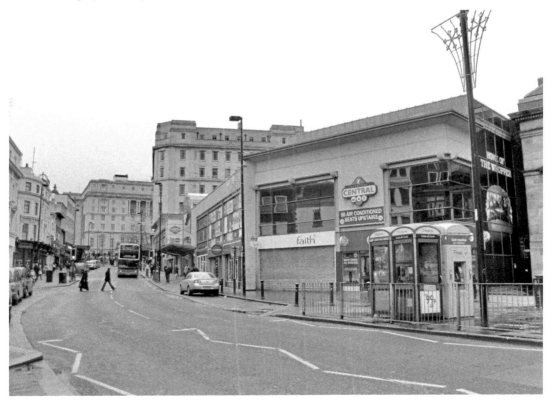

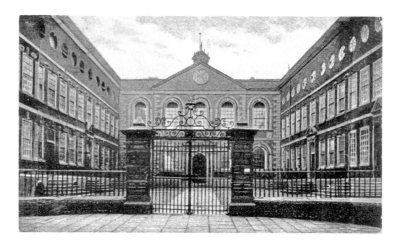

The Blue Coat School

The Liverpool Blue Coat School was founded in 1708 by master mariner Bryan Blundell and the Reverend Robert Styth, the then rector of Liverpool. The Reverend Styth organised 'a place where poor children could be accommodated, cared and learn to read, write and cast accounts'. The financial backing was provided by Blundell. The original building was in School Lane, and in 1719 a new building was erected in the style of Queen Anne. When the Reverend Styth died in 1713, Blundell noticed that the poverty of the time was causing the children to neglect their school work, and he changed the school into a boarding school, providing food, drink and lodging to the pupils. The school was extended in 1718, and the finance was again provided by Blundell. Bryan Blundell died in 1756 and was succeeded by his son, and later his younger brother. A school uniform was introduced which was used by pupils until 1948. By the end of the nineteenth century it was clear that a new school building was required, and this was completed at Wavertree in 1906; in 1948, it became a day and boarding school for boys only. Girls were admitted to the Sixth Form only in 1990, and from September 2002 they were admitted into the school alongside boys following an entrance examination.

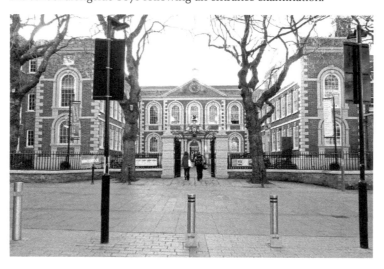

Dale Street
Looking up Dale Street towards the Municipal Annexe.

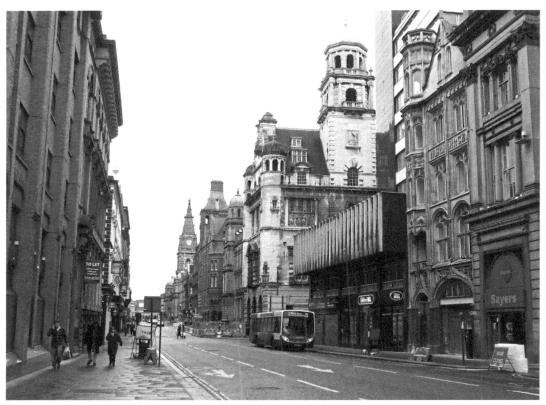

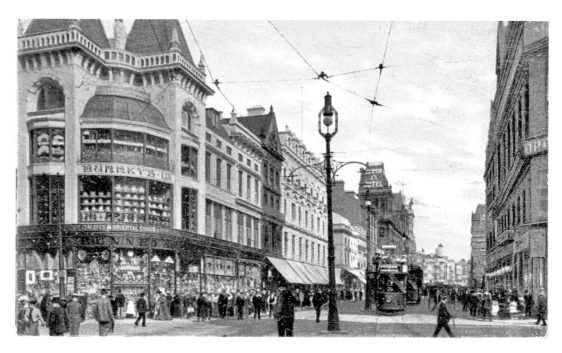

Church Street
The corner of Church Street and Whitechapel.

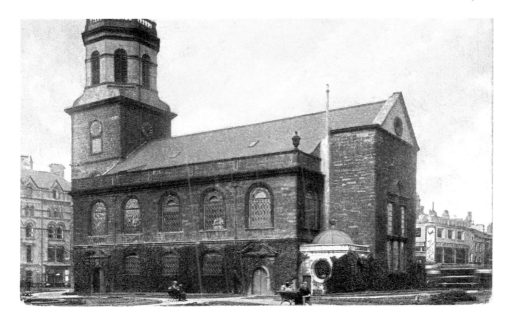

St Peter's Church

Liverpool became a separate parish from Walton in 1699 and money was raised to build a new church, which was to be dedicated to St Peter. The church was designed by John Moffat, and it was built at a cost of £4,000 and consecrated on 29 June 1704. By 1767, the town was divided into five wards named St Nicholas, St George, St Peter, St Thomas and St John. In 1831, the church clock was lit by gas for the first time, and in 1868 the bodies were moved from the churchyard and re-interred at Anfield Cemetery. On 21 April 1901, a memorial service was held after the funeral of Queen Victoria. However, the last service took place in the church in September 1919, and the building was demolished in 1922. A small brass cross marks where the church once stood in Church Street.

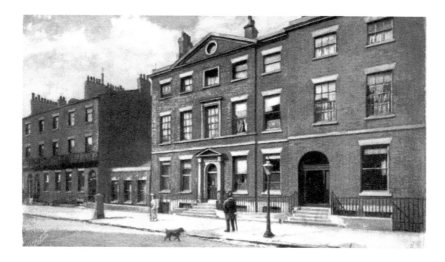

Gladstone's Birthplace

Number 62 Rodney Street was built in 1796, and is the birthplace of William Ewart Gladstone, who was born there on 29 December 1809, the son of a prosperous merchant. Educated at Eton and Oxford University, he was elected to Parliament in 1832 as a Tory. He held junior offices in Robert Peel's government of 1834-1835 and entered Peel's cabinet in 1843, becoming a Liberal-Conservative in 1846. Gladstone joined the Liberal Party in 1859, becoming their leader in 1867 and Prime Minister the following year. He disestablished the Irish Protestant Church in 1869, and was defeated by Benjamin Disraeli in a general election in 1874. He then retired as Liberal leader, but became prime minister again in 1880; his government was defeated in 1885 and he resigned. However, he was prime minister again in 1886 and 1892, and devoted a great deal of time to issues concerning home rule for Ireland. He resigned in 1894 and died of cancer on 19 May 1898, and was buried at Westminster Abbey.

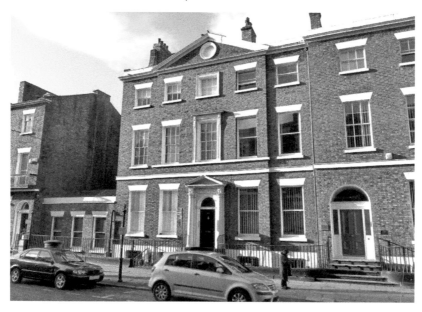

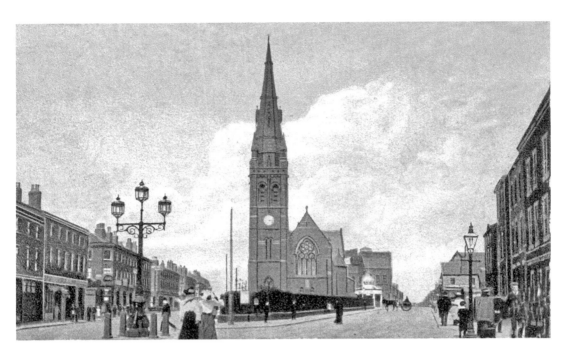

Emmanuel Church

Emmanuel Church in West Derby Road was opened on 15 February 1867, and was erected by Thomas D. Anderson at a cost of £15,000. It was demolished in 1974.

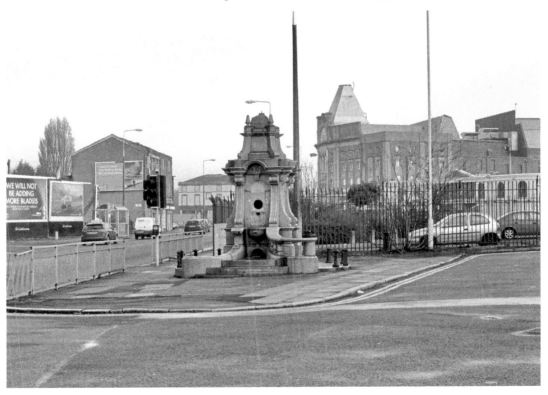

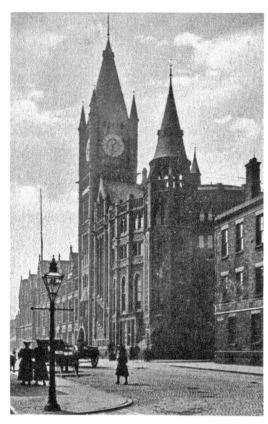

The Victoria Building
The Victoria Building, at the University of Liverpool in Brownlow Hill.

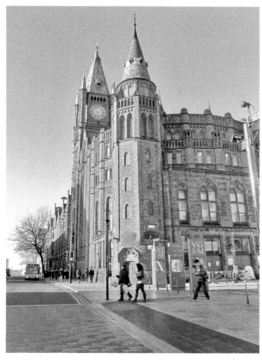

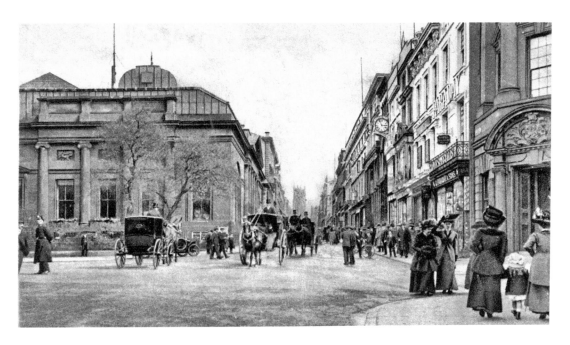

Bold Street – the Centre of Liverpool

The bottom of Bold Street is always busy, and many regard it as being the central point of the city centre. On the left of the photograph is the Lyceum Gentlemen's Club, which was built in 1803 and also contained a library.

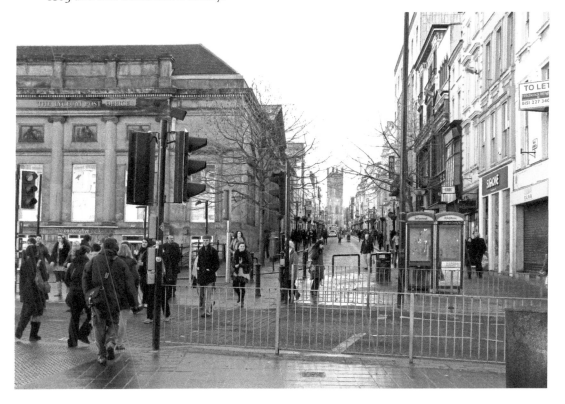

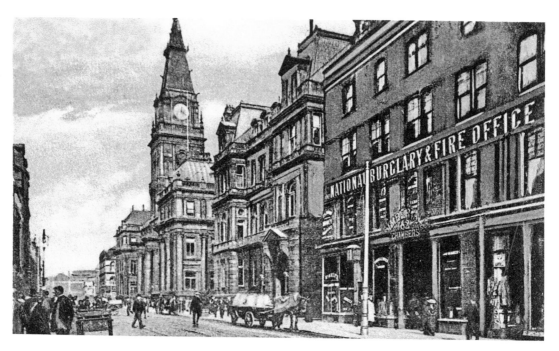

The Municipal Buildings

The Municipal Building and Municipal Annexe in Dale Street.

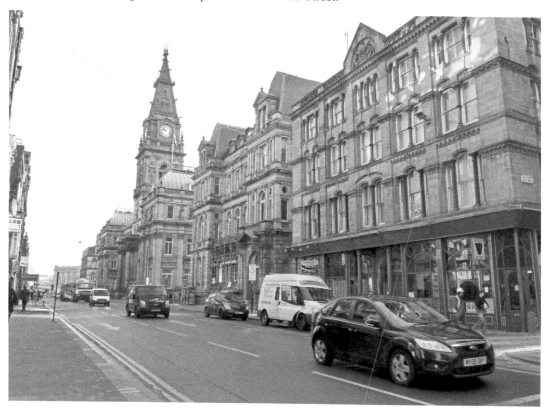

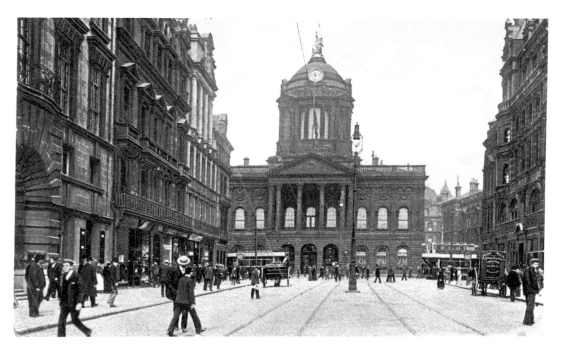

Liverpool Town Hall
The Town Hall in Castle Street.

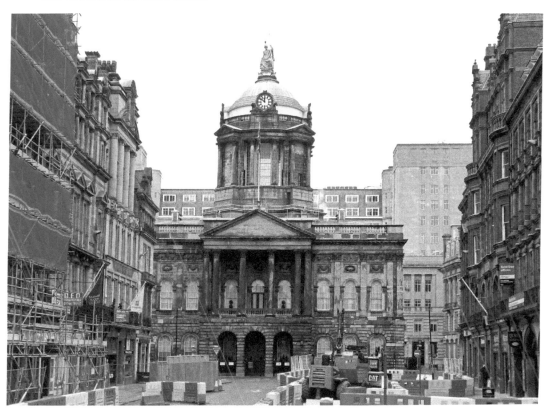

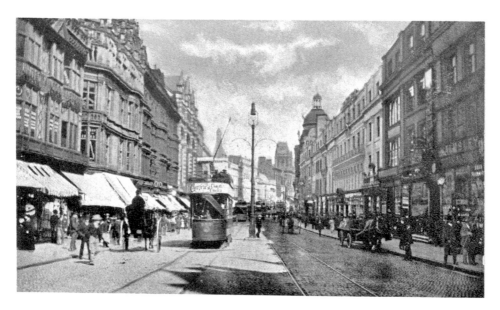

Lord Street

Lord Street was originally known as Molyneux Lane or Lord Molyneux Street. Molyneux had a house on the north side of Lord Street, and after it was demolished a commercial building called Commerce Court was built on the site, and it bore the Molyneux arms carved in stone. The building was destroyed during the Second World War and the carved arms were lost. The inset shows Street in the 1920s. Most of the buildings on the right-hand side of the road were bombed in the blitz, and later demolished after the Second World War.

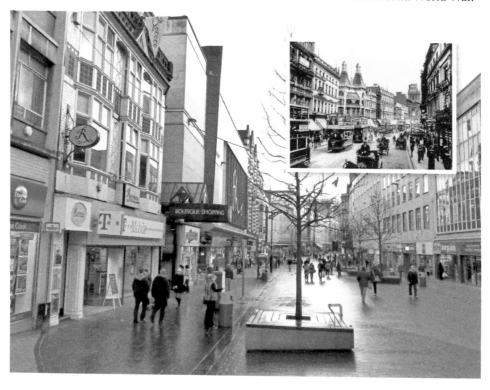

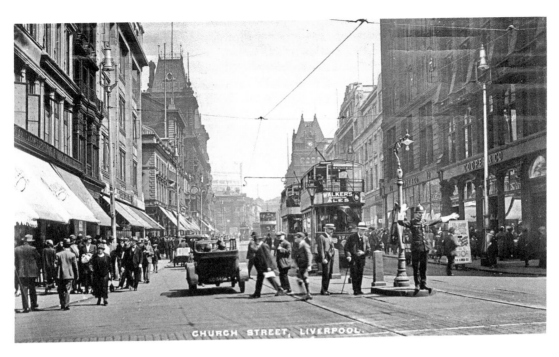

Church Street and the Compton Hotel

Church Street. The inset shows the Compton Hotel, which by 1931 had been taken over by Maison Lyons and Marks & Spencer as a department store.

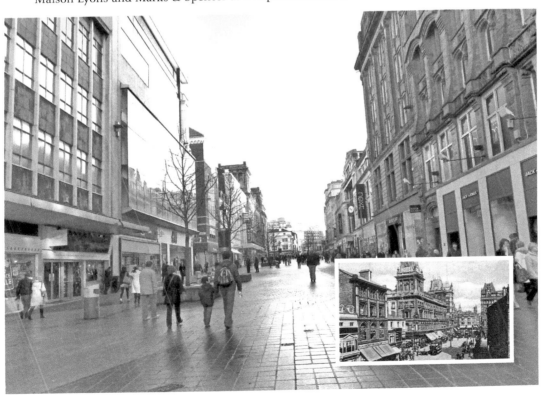

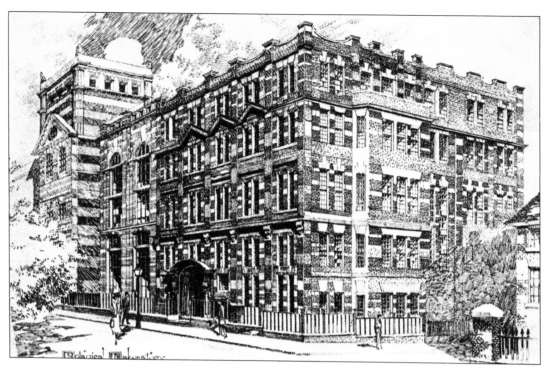

The University of Liverpool

This building at the University of Liverpool was originally the Zoology Department, and now houses the Department of Engineering, the Student Support Office, the Pumphrey Active Learning Laboratory and the School of Archaeology, Classics and Egyptology.

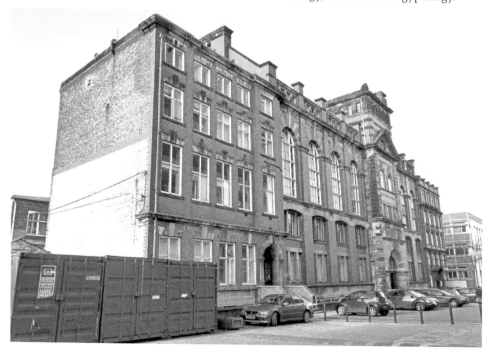

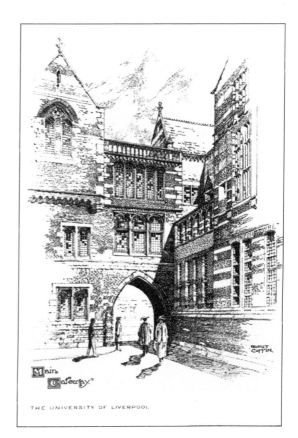

THE UNIVERSITY OF LIVERPOOL

The Victoria Building
The University of Liverpool, Main
Gateway, under the tower at the Victoria
Building leading to Brownlow Hill

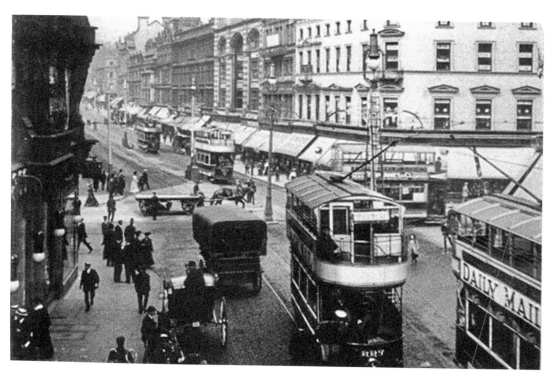

Lord Street
The junction of Lord Street and Whitechapel.

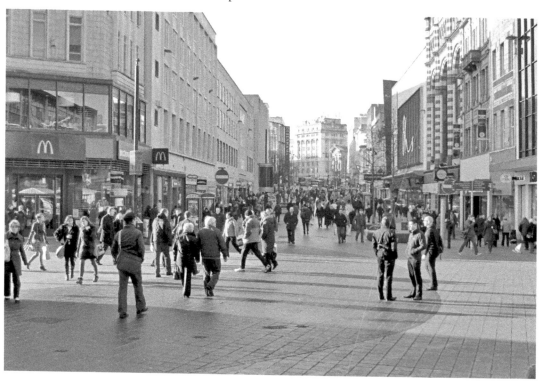

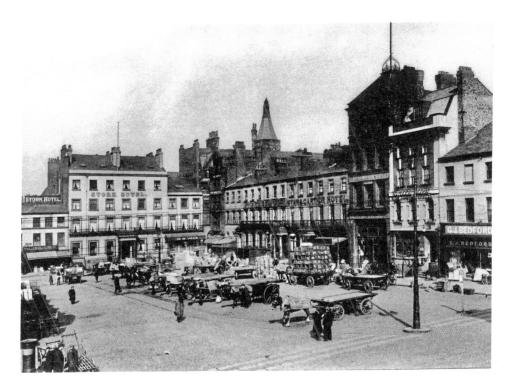

Queens Square

Queens Square in 1920 when most of the major fruit merchants traded from this part of
the city centre. Demolition of the whole area began in the 1970s, and it is now the main
bus station in the city centre.

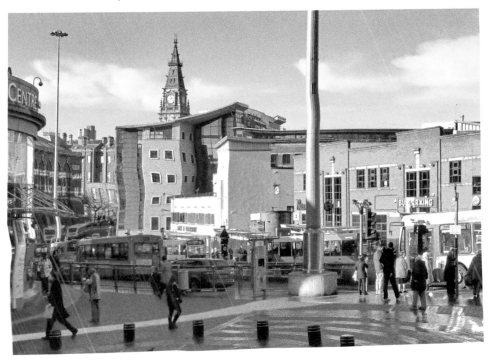

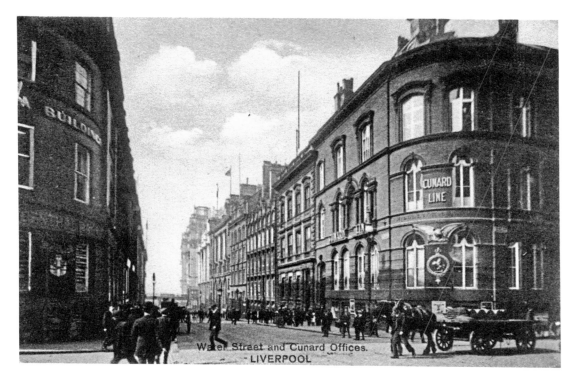

Water Street and Cunard Offices.
- LIVERPOOL

Cunard Offices

The old Cunard offices on Water Street, *c.* 1905 (above) and the new offices, opened during the First World War (below). The current building, now owned by the Merseyside Pension Fund, was originally home to Cunard's transatlantic services, with ticket office, booking area and baggage storage. The *Mona's Queen* last saw passenger service in 1990, but was laid up until 1995 in Birkenhead, before being sold to the Far East.

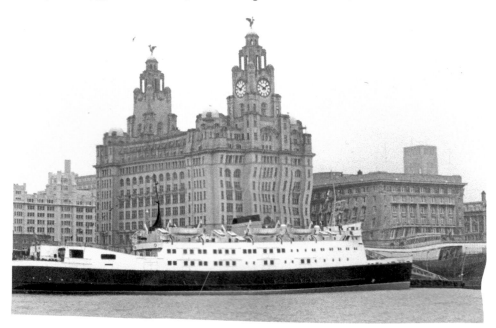